The Consumer's Guide To Probiotics

The Complete Source Book

S.K. Dash, Ph.D.

This information is presented by independent
scientific and medical experts whose sources
of information include studies from the world's
medical and scientific literature, clinical and
anecdotal reports, and the doctors' personal
experiences with family, friends, and patients.

Book Design by Lauren MacLaughlin and
RP Graphic Design Studio
Cover Design by Bonnie Lambert

ISBN 1-893910-33-4
First Printing
Printed in Canada
Published by Freedom Press
1801 Chart Trail
Topanga, CA 90290
Bulk Orders Available: (310) 455-8952
E-mail: info@freedompressonline.com

ACKNOWLEDGEMENTS

I would like to thank everyone who helped to make this book possible. I am so grateful that I could add a personal touch to the scientific evidence, because that is really what this book is about—improving lives in a healthy and natural way.

Thank you to the people at Freedom Press: Mr. David Steinman, Ms. Kim Henderson, and Ms. Jodey Brown who served as editors through various stages of the process and made the completion of this project possible.

And I would like to thank my wife and my family who supported me through all the stages of the process.

—S.K. Dash, Ph.D.

TABLE OF CONTENTS

Foreword
Harry Preuss, M.D.

Introduction
The Surprising Story Behind Probiotics

FOREWORD

"Probiotics" may be a new word to some of you. For others, it might sound familiar. Most people know that antibiotics are drugs used to kill bacteria in the body. But probiotics are just the opposite. Their purpose is to promote the growth of friendly bacteria in the body.

These organisms are also called intestinal flora, gut flora, or microflora. To distinguish good microbial cultures from the others, the term "probiotics" arose to prominence in the nutritional science world.

While, the word *antibiotic* means *against life*, the word *probiotic* actually means *for life*. You've probably been consuming probiotics all of your life and just have not realized it. For example, fermented foods such as yogurt and kefir are sources of beneficial lactic acid bacteria, which your body requires for health. However, lactic acid bacteria such as acidophilus are only one of some four hundred species of different bacteria in your gastrointestinal tract. Scientists have identified more than two hundred strains of lactobacillus alone.

Strange as it may sound, your life depends upon your gastrointestinal tract being populated by friendly bacteria. The amount of bacteria present in the digestive system is so huge, they are counted in powers of 10: 10^3 is 1,000 and 10^6 is 1,000,000. In the esophagus, the amount of bacteria ranges from 10^3 to 10^6 per gram of contents. In the small intestine there are about 10^3 to 10^6 bacteria per gram. This increases in the large intestine (or colon) to 10^8 to 10^{11}. In the feces, ten to twenty percent of the weight consists of bacteria, most of which are anaerobic; that is, they can grow without oxygen.

Throughout history, civilizations of people have benefited from the use of cultures of probiotics. Whether the growth of these bacteria came from sour cream, cheese, kefir, yogurt, sauerkraut or kim chee (fermented cabbage), miso (fermented soy), or other foods, there has been prominent use of probiotics, even by those who didn't know why it helped—only that it did.

Even prior to our first breath we are exposed to probiotics. On the way through the birth canal a normal-delivery child gets dosed with the bacteria of the mother's vaginal tract. The prominent normal organisms in this area, in a healthy woman, called Doderlein's bacilli, are recognized to be a strain of lactobacillus. This starts colonization, right from the very beginning, into the infant's gastrointestinal tract, and may be one of several reasons that caesarean-section babies have a bit of a tougher time with health issues than normal-birth babies. There are also differences (which you might expect) in the make-up of the intestinal flora between breast-fed and formula-fed babies.

As we mature and fully enter adulthood, many threats to our friendly bacteria exist—particularly antibiotics, chlorinated drinking water, and highly processed foods. Thus, probiotics contribute to our health throughout our entire lifetime, and they help fight illness and disease.

This good microflora in your intestine can provide a protective effect only when a proper balance is maintained among all the different bacteria that normally reside in your intestine. If your normal bacteria become depleted or the balance is disturbed, potentially harmful bacteria can overgrow and become established, causing digestive and other health problems. These harmful bacteria are known as pathogenic bacteria, and they have the ability to cause gastrointestinal problems such as diarrhea or abdominal pain if not kept in check by the beneficial bacteria.

The most frequently used probiotic genera are lactobacilli and bifidobacteria. The potential mechanisms of their action include competitive bacterial interactions, production of antimicrobial metabolites, mucosal conditioning, and immune modulation. The emerging use of probiotics in several gastrointestinal disorders (e.g., inflammatory bowel disease) has led to increased interest in their use in patients with irritable bowel syndrome.

The concept of orally taking mixtures of microorganisms for improved health is not new. As early as 1908, Metchnikoff, a Nobel laureate, put a scientific spin on the ingestion of microbes, stating that "ingested lactobacilli can dis-

place toxin-producing bacteria, promoting health and prolonging life."

Until recently, however, this idea has not received serious attention in the United States and Canada. This lack of medical acceptance has probably been due to the ready availability of antimicrobials but also to a previous lack of sound evidence. Another consideration has been the difference in quality of products on the market.

Continued overuse of antimicrobials is leading to serious problems with antimicrobial resistance. Consequently, there is a need for innovative measures to prevent and treat infectious diseases. The therapeutic use of microorganisms antagonistic to pathogens would have the potential to decrease antimicrobial use. Another impetus for a reevaluation of therapeutic microorganisms has been the favorable results of recent randomized, controlled clinical trials testing newer products.

Probiotic bacteria favorably alter the intestinal microflora balance, inhibit the growth of harmful bacteria, promote good digestion, boost immune function, and increase resistance to infection. People with flourishing intestinal colonies of beneficial bacteria are better equipped to fight the growth of disease-causing bacteria. Lactobacilli and bifidobacteria maintain a healthy balance of intestinal flora by producing organic compounds—such as lactic acid, hydrogen peroxide, and acetic acid—that increase the acidity of the intestine and inhibit the reproduction of many harmful bacteria. Probiotic bacteria also produce substances called acidophillin or bacteriocins, which act as natural antibiotics to kill undesirable microorganisms.

Beneficial bacteria present in fermented dairy foods—namely live culture yogurt—have been used as a folk remedy for hundreds, if not thousands, of years. Yogurt is the traditional source of beneficial bacteria. However, different brands of yogurt can vary greatly in their bacteria species and potency. Some (particularly frozen) yogurts do not contain any live bacteria. Supplements in powder, capsule, or tablet form containing beneficial bacteria are good sources of probiotics.

One person has been greatly responsible for the popularization of probiotics into the lexicon and medicine cabinets of Americans and peoples of all continents of the world. That person is Dr. S.K. Dash. Now he provides us with what I think to be the most authoritative and easy-to-understand book on probiotics today.

Sincerely,

Dr. Harry Preuss

Harry G. Preuss, *M.D., M.A.C.N., C.N.S., is a professor of physiology, medicine, and pathology at the Georgetown University School of Medicine.*

INTRODUCTION

The Surprising Story Behind Probiotics

Probiotics are very important to our health. I want to spread this probiotic message. Many people say I was the one to introduce modern probiotics to the United States. I'd certainly agree that I have been among the many dedicated researchers and doctors who've documented the amazing abilities of probiotics. But wait a minute. Let me tell this story from the beginning. Let me start back in a time when I was director of the Food and Drug Administration for South Dakota. That was from 1973 to 1980 when one of the biggest challenges animal-based agriculture faced was maintaining the health of large numbers of confined livestock. While on the one hand, antibiotics were very beneficial to the livestock rancher and helped to prevent disease outbreaks, as well as stimulate their growth, government officials, doctors and veterinarians had only begun to recognize that proliferating the use of antibiotics for challenges faced in animal husbandry presented a number of important health hazards. Today of course everyone knows that antibiotics are having a boomerang effect. Besides the fact that some antibiotics are cancer-causing, the most noted effects with animals' antibiotics is the persistence of antibiotic residues in milk, meat and eggs sold to consumers, a form of adulteration creating antibiotic-resistant "super bugs" resistant to commonly used antibiotics. It was a form of inadvertent selective breeding of microbial pathogens we now know is rendering people far more susceptible to infectious pathogens resistant to doctors' antibiotics. Worst of all, when you or a loved one gets sick, your doctor's usual drugs won't even work a lot of the time. So many pathogic bacteria are now impervious to antibiotics. They are the super bugs that we all know about and fear.

In addition, antibiotics could be used in lieu of optimal care of animals. The antibiotics were sometimes being used to compensate for overcrowding and poor sanitation practices. As an animal lover, I could not then, nor now, tolerate such abuses. But, I also understood that the ranchers had no proven alternatives

to turn to; thus, use of antibiotics for animal disease prevention and growth stimulation continued for a number of years.

As director of the state FDA, I believed it was important to find a better solution for animal health—one based on sound science that also took into consideration humane farming concerns. I did not think that antibiotics were the only way to go and something truly bothered me about proliferating the use of medications for otherwise healthy animals.

In my own academic studies, I had become familiar with the work of Russian embryologist and immunologist Ilya Ilyich Mechnikov who won the 1908 Nobel Prize in Physiology and Medicine and was one of the first modern scientists to take up the study of the flora of the human intestine and to draw attention to the health promoting benefits of probiotics.

So we come to the word probiotics. If an antibiotic is against life (i.e., biota) then a *pro* biotic is *for* life. Probiotics are considered in America to be nutritional supplements containing live microbial organisms that beneficially affect the host by improving the balance of bacterial species in the gastrointestinal tract. Think of them as food supplements, but with a twist—they are alive or, at least should be, if you are purchasing the right product. These supplements help to replace bacteria in the gut that have been decimated by modern living. In fact, his research revealed that a healthy population of beneficial flora is very important to human life, especially immune function. We simply cannot exist without adequate supplies of our body's own beneficial bacterial species.

Based on the Mechnikov model, *Lactobacillus acidophilus* was used in the form of acidophilus milk to treat constipation and diarrhea in the 1920s and 1930s in the United States, often with positive results. Unfortunately, some companies began to recklessly exploit the solid science that Dr. Mechnikov had developed. Commercial acidophilus supplements were marketed, but they were decried by serious researchers for their lack of any viable *L. acidophilus* bacteria. When the public derived no benefits from the inert "acidophilus supplements," interest among the general public waned.

I also learned from my studies that in the 1950s a probiotic product actually had been licensed by the U.S. Department of Agriculture as a drug for the treatment of a disease known as "scour" in pigs and calves, which is caused by *E. coli* infection. Similar to what Mechnikov had found in humans, by supplying viable cultures of beneficial bacteria, this probiotic supplement was 97 percent

effective in combating *E. coli* infection in pigs, a cure rate as effective as the antibiotic neomycin sulfate, the standard treatment. Unlike antibiotics, however, the natural probiotic posed no unwanted side effects, left no harmful drug residues in the edible portions of the pork, and was relatively inexpensive. Plus, the probiotic supplement provided many benefits that led to overall health among farm animals.

So what happened to this great probiotic product? Unfortunately, for consumers and ranchers alike, the big pharmaceutical companies used millions of dollars in research, development, marketing and promotion and took over the market with antibiotics—the miracle drugs of the time. In this period of time (early 1950 to around the 1970s), particularly in America, the probiotic firms were rendered to the fringe economy, like the earlier 20th Century ones I had read about that ultimately lacked the monies or income to compete with the big drug firms in research, development, marketing and promotion. Probiotics lost out big in the battle against antibiotic manufacturers. But the war isn't over, and now probiotics have the upper hand and are gaining ground. They will never replace medical drugs. Remember, probiotics are considered to be largely a dietary supplement, not a drug or a cure. So you will still need antibiotics—but perhaps, in their greater wisdom, doctors will prescribe them only when necessary and less often because of our overall collective improved digestive health. You see, probiotics have a lot to offer the world when it comes to improved health. That is my message.

Times Change

Lack of public interest and consumer and scientific skepticism combined with a far more lucrative market for antibiotic medications—that was where probiotics were in the late 1970s in America.

Yet, ironically, at the very height of antibiotics' popularity, increasing concern with our over-reliance on these modern miracles of medicine led to a boomerang effect. The initial observations of many researchers, who had warned about the health hazards of indiscriminate use of antibiotics, were shown to be accurate. The many side effects from both veterinary and human use of antibiotics were becoming, and remain, quite serious. These included increased incidences of antibiotic-resistant super strains of pathogens and a wide range of human pathologies now associated with pervasive dysbiosis (bacterial imbalances in the

human gastrointestinal tract, often caused by frequent antibiotic use). These neg-ative health outcomes demanded serious responses from the informed and inde-pendent medical and scientific communities. If we were going to get serious about making probiotics work, though, we had to set standards that would live up to the results obtained in published scientific research.

While working for the government, I played an integral role in introducing quality control standards for probiotics. These are now used worldwide by the probiotics industry. They basically included ensuring that consumers, humans and animals, received "live" cultures which would safely implant for a time period in the gut of the human or animal, leading to improved health. You might notice probiotics are usually refrigerated. That helps preserve cultures. Not all need it, but do be wary of those claiming no refrigeration. Some can survive two years without it, but it ensures the viability of the probiotic cultures.

Interestingly, it was the natural health community that was best positioned to provide viable antibiotic alternatives.

Times Beyond Antibiotics—Meeting the Challenge of Modern Probiotics

I left my service with the South Dakota FDA at the end of 1980. My first goal was to implement some of these greater findings that Mechnikov and other qual-ity longevity researchers had been looking at. I believed that the 1980s would be a time for the public to rediscover probiotic supplementation and this trend has continued since.

From my work, I knew of some interesting work was going on at the Department of Dairy Science at the University of Nebraska. University of Nebraska scientists researched a strain of *Lactobacillus acidophilus* that was very good for human health because it colonized well in the human gut and pro-duced good effects on the host species. They called it DDS®-1.

It has been found that this specially researched probiotic strain possessed properties important to digestion and general health. For example, it produced enzymes (such as proteases and lipases) to aid the body's digestion of proteins and fats, respectively. The strain also was found to produce significant quantities of lactase, thereby alleviating lactose intolerance caused by the deficiency of the lactase enzyme and reducing the possibility of bad breath, bloating, gas forma-tion and stomach cramps, which are associated with such milk sugar intoler-

ance. Other documented benefits, perhaps of even greater significance, were the strain's antibacterial actions, which were essentially equivalent to those of antibiotics. In fact, it had been discovered that this strain produced a potent natural antibiotic called acidophilin. We have since discovered many benefits to be derived from probiotics. Today, more than 200 papers on this bacterial strain alone have been published in peer-reviewed scientific and medical journals over a period of more than 40 years. But at the time when probiotics were in their infancy, DDS-1 *L. acidophilus* was not commercially manufactured and was unavailable to the consumer. I formed UAS Laboratories in the late seventies, which became the first commercial manufacturer of probiotic supplements with DDS-1 *L. acidophilus.*

Today, we think of the delivery of probiotics as something to be taken for granted. I assure you both past and recent testing indicates that this is still a goal for altogether too many products. (Although the best products deliver superb results.)

At UAS Labs, the company I formed, which is based in Minnesota, USA, we worked to put into place safeguards guaranteed to insure product integrity and promote confidence.

Among our early accomplishments:

- Implement a unique process of commercially producing, freeze-drying and naturally stabilizing the bacterium for delivery to consumers.
- Introduce non-dairy probiotics.
- Introduce quality control standards for probiotics, including requiring guaranteed numbers of viable bacteria (expressed as colony-forming units per gram or CFU/g). This is now used worldwide.
- Package probiotics with nitrogen to improve their stability.
- Prove that DDS-1 *L. acidophilus* can pass through stomach acid, implant in the intestines, and multiply 100 to 200 fold.
- Incorporate the prebiotic fructooligosaccharides (FOS) with probiotics to enhance their growth in intestines. (Don't overlook the value of FOS; it's literally "food" for your intestinal flora.)
- Improve the stability of DDS probiotics for two years at room temperature by using patented technology from University of Wisconsin/WARF.

All of these innovations have been incredibly important to the probiotic supplement and have provided leadership in its most meaningful format—by example.

Today in health food stores and supermarkets' natural health sections you see probiotics containing *Lactobacillus acidophilus, Bifidobacterium longum, Bifidobacterium infantis, Bifidobacterium bifidum*, some of the most common families found in probiotic products.

Keys to Health

The scientific research on probiotics shows many health benefits:

- Improved digestion of foods and alleviating digestive disorders.
- Enhanced synthesis of B vitamins.
- Protection against *E. coli* and other food poisoning type infections.
- Improved lactose tolerance and digestibility of milk products.
- Reduced risk of vaginal infection and yeast infection.
- Improved immune function.
- Promoting anti-carcinogenic activity.
- Helping to prevent peptic ulcer caused by *H. pylori*.
- Preventing acne.
- Reducing cholesterol.

In today's modern world, probiotics are needed more than ever. It is apparent that our polluted environment, consumption of processed foods and chlorinated water and heavy use of antibiotics and other medications can destroy the friendly microflora of the gastrointestinal tract, thus making the body susceptible to yeast infection and other diseases. Research shows that seventy percent of women and forty percent of men have yeast infections to some degree as a result of heavy use of antibiotics, cortisone drugs, and poor eating habits. Studies done at the Minneapolis VA Hospital show that the average man or woman no longer has adequate populations of friendly bacteria in their intestines. Supplementation with probiotics has been demonstrated to enhance the presence of these friendly bacteria in the intestine, leading to greater populations of beneficial bacteria and many positive health benefits. In fact, I think we all know the importance of taking a multivitamin for our health. Many doctors now say a quality probiotic supplement is as important to your health as multivitamins. I would be hesitant to disagree. Or, to be blunt, I shall agree wholeheartedly.

Part I
Probiotics — An Overview

Chapter One

THE ECOLOGY OF YOUR GUT

This may surprise you. But the next trend at the health food store or pharmacy, that is already occurring, is the sale and consumption of dietary supplements that replenish the populations of beneficial bacteria in your body that fight diarrhea and other illnesses. Indeed, as Christine Gorman, of *Time* notes, "Say the word bacteria, and most folks conjure up images of a nasty germ like staphylococcus or salmonella that can make you really sick. But some bacteria aren't bad for you. In fact, consuming extra amounts of some bacteria can actually promote good health…." So far, the best results have been seen in the treatment of diarrhea, particularly in children. But researchers are also looking into the possibility that beneficial bacteria may thwart vaginal infections in women, prevent some food allergies in children and lessen symptoms of Crohn's disease, a relatively rare but painful gastrointestinal disorder.

So where have these good bacteria been lurking all your life? "In your intestines, especially the lower section called the colon, which harbors at least 400 species of bacteria," notes Gorman. "Which ones you have depends largely on your environment and diet. An abundance of good bacteria in the colon generally crowds out stray bad bacteria in your food. But if the bad outnumbers the good—for example, after antibiotic treatment for a sinus or an ear infection, which kills normal intestinal bacteria as well—the result can be diarrhea."

In this regard, and for other reasons, enhancing the GI system's population of friendly bacteria represents an exciting therapeutic advance in treatments for many conditions.

One of the areas of health now being studied most intensively is the body's

gastrointestinal (GI) system. This is because of its direct contact with consumed foods and the complexity of its functions regarding nutrient assimilation and healthy immune function. Not surprisingly, health experts say the GI system is a potential target for many functional foods and dietary supplements. They say, and rightly so, it is the gate to systemic health or unhealth. Since probiotic supplements supply beneficial bacteria to the GI system, these supplements can provide incredibly important health benefits. These benefits are particularly dramatic among the infirm and unhealthy. For those who enjoy good or great health, probiotic supplements can help increase their resistance to disease and maintain their good health.

Generally speaking, intestinal bacteria can be divided into two broad groups: those that are beneficial to the host organism and those that are harmful. Similarly, it is increasingly being recognized that the microbiology of the human GI system—what we call the balance of good to harmful bacteria—can exert a major role in our health, both in a positive and negative manner.

Health-promoting effects of beneficial bacteria include stimulation of the immune system, reducing gas problems, improved absorption of essential nutrients, even synthesis of vitamins. We should also note that beneficial bacteria help us to maintain healthy cholesterol levels, fight cancer and even promote resistance to food-borne pathogens. In contrast, pathogenic effects of harmful bacteria include diarrhea, infections, liver damage, cancer, heart and circulatory problems, diabetes, and intestinal putrefaction.

That doesn't mean we want to eliminate the so-called bad bacteria in our gut. All bacteria, good and bad, are important—much as all animal species are important to an ecological system. Each bacterial species that grows in the colon has a specific ecological niche to fill. The composition of bacteria—that is, the relative distribution of the "good" and the "bad" bacteria—in an individual's colon remains fairly stable over long periods of time. As such, there is a finely tuned balance in the colon from which the body derives health benefits and the digestive system works smoothly without causing any ailments or discomfort.

The problem is, of course, that very often today the balance of good to bad bacteria is disrupted. I'll tell you why in a little bit, but, for now, that's why an important aspect of health promotion today is favorably altering the composition of the gastrointestinal micro-flora towards a potentially more healthy community. As such, attempts have been made to increase numbers of beneficial

bacterial species (such as lactobacilli and bifidobacteria), both of which may exert various health-promoting properties.

A Closer Look at Health Benefits of Probiotics

A healthy population of friendly bacteria in your gastrointestinal tract is critical to your overall health. Indeed, few people realize the enormous impact of pathogenic bacteria, parasites and intestinal disorders on human health.

"Even human intestines—an environment most people consider pretty familiar—are home to perhaps 10,000 kinds of microbes…Indeed, one of the surprises in the decoding of the human genome was that it contains more than 200 genes that come from bacteria. Microbes not only keep us alive; in some small part, we are made of them. Researchers are now looking at how these largely unknown microbes might play a role in Crohn's disease, an inflammation of the small intestine. They have found that the makeup of the mixed 'community' of microbes in the intestines changes in people with the disease. A similar thing might happen with tuberculosis…leading [researchers] to wonder whether some diseases might be caused not by a single dangerous microbe but by a change in the microbial community—an ecological imbalance inside the human body."

So there you have it. Our health depends on countless numbers of microorganisms and our gut is also populated with far more microbes than we have ever known. Inside and out we are at one with the microbial world.

As already mentioned, probiotic is the term used to describe the health-promoting microorganisms, the "friendly" bacteria, in your digestive system. This good microflora in your intestine can provide a protective effect only when a proper balance is maintained among *all* the different bacteria that normally reside in your intestine. If your normal bacteria become depleted or the balance is disturbed, potentially harmful bacteria can overgrow and become established, causing digestive and other health problems. These harmful bacteria are known as pathogens, and they have the ability to cause gastrointestinal problems such as diarrhea or abdominal pain if not kept in check by the beneficial bacteria.

"When *L. acidophilus* bacteria are present in sufficient numbers, they prevent invading pathogens and opportunistic organisms from finding 'parking spaces' along the walls of the intestine, where nutrients cross into the bloodstream," says medical anthropologist Dr. John Heinerman. "If too many harmful

bacteria manage to set up colonies, nutrient absorption can be blocked. Fortunately though, when the walls are crowded with acidophilus colonizers, there is no room for newcomers and no way for opportunistic microorganisms to exceed their boundaries. A very desirable characteristic of *L. acidophilus* super strains is that they adhere naturally to the walls of your intestines. These strains, known as *sticker strains*, are the most desirable because they hang onto their parking spaces with great tenacity—without harming the intestinal wall. Most pathogens, like disease-carrying *E. coli*, literally bore holes in the intestinal wall, inducing numerous micro-infections."

However, once the small intestine is colonized by a healthy population of beneficial bacteria, "things begin to happen very quickly," notes Dr. Heinerman. The 'nasties' are compelled to either vacate their premises or else are held in check by the more muscular *L. acidophilus* bacteria."

The increased interest in probiotics as a daily dietary supplement has led to ongoing research. Probiotics can aid your health in many ways and help you to meet the healing challenges posed by many different health conditions. Taking a quality probiotic supplement today is as important to your health as taking a multiple vitamin and mineral formula.

Take diarrheal diseases (bacterial as well as parasitic). Worldwide, these con-stitute the greatest single cause of morbidity and mortality today. Even in the United States, diarrheal diseases caused by intestinal infection are the third lead-ing cause of morbidity and mortality. But in the Third World, the situation is dire, and probiotics could potentially be a very powerful natural remedy for diarrheal illnesses, especially among children.

Even more prevalent than acute diarrheal illnesses is the occurrence in Western nations of more subtle intestinal bacterial imbalances that produce a host of common symptoms and result in an obvious lack of wellness. We may know this condition as irritable bowel syndrome or simply dyspepsia or excess gas. This condition can also be traced to imbalances in the gut flora. So that means just about everyone in the country could probably find a probiotic sup-plement beneficial!

In addition, poor immune function, increased risk of cancer and frequent infectious conditions are all intimately related to the balance of beneficial bac-teria in your gastrointestinal tract.

Enemies of the Good Guys in Your Gut

An imbalance in your gut flora is referred to as *dysbiosis*. Put simply, dysbiosis is one of those fancy words for a condition that occurs when the population of organisms residing within the gastrointestinal tract becomes unbalanced, often resulting in acute or chronic sickness.

Normally, populations of pathogenic flora are kept in balance by competition from good bacteria and because of *symbiosis*, which is the mutually interdependent relationship among the hundreds of intestinal microbial species. The problem is that our modern lifestyles—including, as mentioned earlier, use of antibiotics and other antibacterial products, consumption of chlorinated water and excess intake of refined sugars found in candy, baked goods and soft drinks—has left many people with an imbalance of beneficial to pathogenic gut bacteria.

A healthy intestine, in both children and adults, contains billions of friendly bacteria—including up to 400 different species. Incredibly, the body's beneficial bacteria outnumber the cells of the body by one hundred fold!

These friendly bacteria are our first line of immune defense. They displace and fight off unfriendly bacteria and internal fungi that can set the stage for both adult and childhood illness. They even increase the body's levels of interferon, a mighty immune-boosting hormone.

This is all very critical to our health. If harmful bacteria propagate and gain the upper hand, we will not only be prone to infectious disease but our bodies will produce toxic, carcinogenic substances. We will also suffer constipation and diarrhea.

But here's the problem that adults—and children especially—face as they grow up in a toxic world. Stress, medications and poor diet reduce friendly bacteria even further, leaving them even more vulnerable to disease. Antibiotics can be the biggest culprits in destroying our friendly bacteria. At high dosages, they wipe out all bacteria inside your body, the good along with the bad.

Once that happens, the race is on as to which microorganisms, the good guys or the bad guys, set up shop in that empty real estate inside yours or your child's gut.

Even if we don't take antibiotics, we almost certainly consume them in animal products. Over 35 million pounds of antibiotics are produced in the U.S. each year, and animals are given the vast bulk of them. Cattle, pigs and poultry

are routinely given big helpings of antibiotics to prevent infections from spreading in their stressful, crowded quarters. In Western Europe, giving antibiotics to cattle is outlawed, as is the importation of American beef; this is, in part, due to all the antibiotics fed to U.S. cattle.

This is why we must be extra careful to replenish and stabilize friendly bacteria in the gastrointestinal tract. In essence, when we help ourselves in this way, we have positioned on our side a massive army of health defenders in our intestines that is ever on guard to protect our health.

Now readers can see why I am so excited about the development of quality probiotics. When consumers are prescribed antibiotics either for short or longer periods, I truly believe that they should also consider the use of probiotics concurrently to maintain and replenish their population of beneficial bacteria. By doing so, they will have gone a long way towards having all of the friendly bacteria they need to keep their intestines clean, healthy and populated with a strong front line of defense to support immune function and overall health.

When the balance of good and bad bacteria is disturbed, the bad bacteria get the head start in repopulating the barren property within your gastrointestinal tract. Dysbiosis results in abnormal fermentation in the small intestine. In the large intestine, some fermentation is desirable because it produces butyrate and other short chain fatty acids that nourish the cells of the intestinal wall.

In the small intestine, however, growth of yeast, fungi and/or fermenting bacteria can result in damage to the gut lining, absorption of toxic by-products, and impaired absorption of nutrients. Opportunistic overgrowth of organisms can lead to common conditions such as candidiasis, urinary tract infections, and prostatitis (an inflammation of the prostate gland).

Quite apart from causing many types of gastrointestinal problems, dysbiosis can also lead to a weakened immune system. As the body further loses its ability to cope with the offending infections and pathogens, a host of chronic conditions appear that, on the surface, may have precious little to do with gastrointestinal disturbances.

That means that gastrointestinal health has far-reaching implications for general health, much more so than is commonly recognized.

Fortunately, the importance to human health of the intestinal microflora has been more and more widely recognized by doctors in recent years. This is probably because ever-increasing environmental challenges (e.g., antibiotics, oral con-

traceptives, food additives and especially processed food and refined sugar) have contributed to the greater prevalence of disharmony in the ecology of the human gastrointestinal tract.

Problems with Antibiotics

Antibiotics are great. They are miracle medicines. When you really need them, take them. But we also have to face the discomforting fact that antibiotics have negative effects too, especially upon the body's beneficial bacteria. Antibiotics are used to kill or inhibit the growth of infectious organisms or pathogenic bacteria. All antibiotics possess selective toxicity, meaning that they are more toxic to an invading organism than they are to the host organism (e.g., the person taking them)—but they still end up killing significant numbers of beneficial bacteria organisms.

Almost any antibiotic will change the bacterial balance in the intestines. Research suggests that the use of antibiotics before surgery results in decreased levels of both aerobic and anaerobic bacteria to between 20 and 25 percent of their original amounts. Given that more and more drug-resistant bacteria are evolving, there is also an increase in prescriptions of highly potent antibiotics. These broad-spectrum, extremely effective antibiotics hit both friend and foe alike, since they are…"equal opportunity" killers. This means that the floral ecology in the intestine is severely perturbed. This ecological vacuum created by the destruction of friendly bacteria is quickly filled by pathogenic microorganisms. With billions of attachment sites open in the intestine, the harmful bacteria have the opportunity to move in and take hold.

The rapid deployment of the bad bacteria leads to the repopulation of the intestine by numerous disease-causing microorganisms. For example, the overgrowth of *Clostridium difficile*, an especially harmful bacterium, gives rise to a condition called Pseudomembraneous enterocolitis. The condition, produced by this opportunistic invader, includes bloody diarrhea, pain, catastrophic weight loss and ulcerations of the intestinal lining.

In his book *The Second Brain* (HarperCollins, 1998), Dr. Michael D. Gershon, chairman of the Department of Anatomy and Cell Biology at Columbia University, College of Physicians Surgeons, dubs the gastrointestinal system the body's "second nervous system." He notes, "The brain is not the only place in the body that's full of neurotransmitters. A hundred million neurotransmitters

line the length of the gut, approximately the same number that is found in the brain… The brain in the bowel has got to work right or no one will have the luxury to think at all." The gut or the intestine is within the body but it is its own world. In experimental studies, even when all nerves connecting the bowel to the brain and spinal cord were severed, "the law of the intestine" prevailed, and digestion continued.

According to Dr. Gershon, "One reason that the bacteria in the lumen of the colon do not break out and infect the body is that they are at war with one another. No one kind of germ gains ascendancy and takes uncontested possession of colonic turf. The constant competition between otherwise nasty germs helps to keep the bacterial population under control."

As Dr. Gershon points out, "It really is a case of 'the enemy of my enemy is my friend.'" Our bacterial companions in the colon may be repulsive, but we still have to take good care of them. Taking an antibiotic, therefore, is not without risk. Killing germs in the colon can be a hazardous venture. Antibiotics that annihilate our colonic friends can get us into big trouble, and fast. Many kinds of bacteria are killed by antibiotics, but not all. Those that are not killed are those that are most resistant. As Charles Darwin pointed out, natural selection is a potent force. When applied to organisms that double in minutes, natural selection is not just potent but fast. Selection of antibiotics is thus not a good move for modern medicine. The therapeutic value of drug after drug has been lost as bacteria adapt to them and circumvent their efforts.

In his book, Gershon says, "Since antibiotics are routinely added to chicken feed and other agricultural problems, the proportion of resistant organisms increases every year. This problem is compounded by the large number of doctors who prescribe antibiotics without first determining whether the disease they wish to treat is due to a susceptible organism. By killing some bacteria and not others, the administration of an antibiotic may eliminate the competition between germs in the colon, so that one strain, which appears to be resistant, achieves dominance. In essence, the drug selects a bug. The resistant strain is thus dangerous for two reasons. One is that it has been liberated from the restrain imposed on it by the other bacteria that normally compete with antibiotic-resistant organisms. The point is that the resistant bacteria are hard to eliminate because it is difficult to find a nontoxic drug that can kill them. The resistant organisms, therefore, are likely to cause a rip-roaring florid colitis infection

of the colon. They can also escape from the colon and invade the body. Some of the antibiotic-resistant strains of bacteria, such as *Clostridia difficile*, make toxins that peel the lining of the colon right off the organ and lead to an explosive, debilitating and frequently lethal form of diarrhea."

Another pathogenic bacterium that can take advantage of the void created by the elimination of friendly bacteria is *Staphylococcus aureus*. Its overgrowth can also result in toxic shock syndrome and can become very resistant, which is known as methicillin-resistant staph or MRSA, requiring far more potent vancomycin therapy.

Reuters news service reports that this drug-resistant form of bacteria has been found in rural Native American communities, demonstrating that these so-called "super bugs" are moving out of their hospital breeding grounds and into the community. According to health researchers the methicillin-resistant *Staphylococcus aureus* (MRSA) strain has been found now in Minnesota among Native Americans living in the countryside. That means the infections resisted treatment with methicillin and can be killed only by vancomycin, which is considered a last-ditch antibiotic.

Only a quarter of the patients with MRSA had been in a hospital, a long-term care facility or had any of the other usual risk factors for getting a drug-resistant infection. Such cases of MRSA infection outside the hospital had been seen before only in isolated incidents in Australia, Chicago and Canada.

Scientists say drug-resistant bacteria evolve when they are exposed to antibiotics over time—which most frequently happens in hospitals. Patients who get antibiotics for months become breeding grounds for the bacteria, because a few will always survive the antibiotic—and these will be the ones genetically predisposed to resist the drug. The longer these survive, the more they multiply and the resistance spreads.

When the friendly bacteria are decimated by antibiotics, other harmful bacteria, yeast and fungi already living in the body, which were held in strict check by the friendly bacteria, begin to multiply profusely. Some of these are resistant to antibiotic medications. The overgrowth of one especially potent yeast-like fungus, *Candida albicans,* leads to a potentially serious condition called candidiasis. Depending on its locale of action, candidiasis can inflame the tongue, mouth or the rectum. It could also cause vaginitis and may be instrumental in triggering a range of mental and emotional symptoms, including irritability, anx-

iety and even depression. Many allergies that manifest themselves as digestive disorders, such as bloating, heartburn, constipation and diarrhea also have been causally linked to yeast overgrowth.

Knowing how to use antibiotics in a safe and effective manner is critically important to doctors, pharmacists, and consumers alike. And to children. The American Academy of Pediatrics recently observed that 95 percent of children in the United States will have been treated with antibiotics for a middle ear infection by the age of five.

Children on antibiotics are especially susceptible to antibiotic-associated bacterial influences that cause diarrhea. Diarrhea may resolve itself, which it normally does, particularly in children, but antibiotics frequently perturb the ecological balance in the colon and allow the overgrowth of harmful bacteria. Left to itself, this imbalance could potentially disturb the intestinal "ecosystem" irrevocably.

Modern Food Processing

Another enemy of our beneficial bacteria is food processing. Before refrigeration, it was quite common throughout the world to use fermentation of foods as a means of preservation. Such practices led to the creation of many different kinds of foods laden with beneficial bacteria that we directly ingested. Fermented foods and drinks have a very long history. Wine already existed around 5000 BC, and the original forms of soy sauce, miso, and fermented milk existed around 3000 to 2000 BC. These fermented products were originally made by microorganisms mixed from the environment. Other examples include sunki and gundruk; masai fermented milk; furu; choutofu; kusaya; funazsuhi; tempeh, mantou; and dawadawa. But, today, refrigeration of foods has diminished our need for fermentation, thus depriving our bodies of important beneficial bacteria.

Costly National Concern

Besides, digestive diseases and other conditions related to healthy or unhealthy balances of intestinal flora have an enormous impact on our health. They are extremely costly in all ways. Digestive diseases, which often are caused in part by, or result in, dysbiosis, cost nearly $107 billion in direct health care expenditures. Digestive diseases result in nearly 200 million sick days, 50 million

visits to physicians, 16.9 million days lost from school, 10 million hospitalizations, and nearly 200,000 deaths per year.

The most costly digestive diseases are gastrointestinal disorders such as diarrheal infections ($4.7 billion); gallbladder disease ($4.5 billion); colorectal cancer ($4.5 billion); liver disease ($3.2 billion); and peptic ulcer disease ($2.5 billion).

Digestive diseases result in nearly 200 million sick days, 50 million visits to physicians, 16.9 million days lost from school, 10 million hospitalizations, and nearly 200,000 deaths per year.

Cancers of the digestive tract, which include those of the colon, gallbladder and stomach, are responsible for 117,000 deaths yearly. Noncancerous digestive diseases cause 74,000 deaths a year, with 36 percent caused by chronic liver disease and cirrhosis.

Of the 440 million acute noncancerous medical conditions reported in the United States annually, more than 22 million are for acute digestive conditions, with 11 million from gastroenteritis and 6 million from indigestion, nausea, and vomiting. Probiotics, in this context, can play a major role in our health. They're the counter to the antibiotics we are exposed to in drugs, milk, meat and eggs.

The bottom line remains: the human body requires beneficial intestinal flora in optimal numbers for optimal health; many environmental and dietary conditions threaten their balance.

Not surprisingly, dysbiosis, its prevention and treatment are among the most topical and challenging problems doctors face today. In dysbiosis, even organisms traditionally thought to have little ability to cause disease, including usually benign bacteria, yeasts, and some parasites, can induce illness by altering our nutritional status or immune response.

Effects can be as diverse as headaches, learning disorders, insomnia, immune dysfunction, behavioral disorders, chronic fatigue, joint pain, and many types of nutritional deficiencies. Abnormal gut fermentation has adverse effects on B vitamins, zinc and magnesium.

For longevity, and to assure optimal protection from age-related illness, having a healthy colon is of immeasurable importance.

Clearly, maintenance of bacterial balance in the intestine is critical for intestinal health. Dietary changes and food supplements are essential and used frequently to restore beneficial bacteria, normalize digestive function and repair the gut. High fiber, low sugar diet and increased water intake are also vitally important to maintain healthy intestinal ecology.

However, many people will greatly benefit by positioning probiotics on their side. These supplements are powerful gastrointestinal health enhancers.

Dysbiosis Symptoms & Causes

Common Symptoms

- Fatigue
- Flatulence
- Itchy anus
- Poor complexion
- Fatigue after eating
- Distention/bloating
- Inability to lose weight
- Constipation or diarrhea
- Irritable bowel syndrome
- Abdominal pain or cramps
- Irregular bowel movements
- Rheumatoid arthritis
- Colon cancer
- Poor digestion
- Food allergy
- Spastic colon
- Hypoglycemia
- Leaky gut syndrome

Major Causes

- Poor diet—excessive sugar, fat or animal protein
- Stress—including long term emotional stress
- Decreased immune function
- Decreased intestinal motility (constipation)

- Drugs—especially antibiotics, oral contraception and cortisone-like substances.
- Maldigestion and malabsorption

According to authoritative natural remedy source healthnotes.com, a very definitive ranking of probiotics' uses in health today is available. Probiotics have been used in connection with the following conditions:

Health Concerns

- Diarrhea
- Tooth decay
- Vaginitis
- Yeast infection
- Canker sores
- Colic (*Bifidobacterium lactis* and *Streptococcus thermophilus*)
- Crohn's disease
- Eczema
- Food allergies
- HIV support
- Immune function
- Infection
- Pancreatitis (acute) (*Lactobacillus plantarum*)
- Ulcerative colitis
- Chronic candidiasis

Part II

Health Conditions & Probiotics

Chapter
Two

DIGESTION AND NUTRIENT UTILIZATION

D o you ever think about what goes into your body each day? You should. The key to feeling good and being healthy is eating nutritious food and taking care of your insides, particularly the gastrointestinal tract, which consists of the stomach and intestines. The GI tract is an important component of your digestion, which works to process food and waste.

As I have written in past books on the subject of probiotics and digestion, I believe that digestive health is a significant contributor to overall health.

So we really do want to keep our digestive health up to par. Probiotics can really help.

As we have discovered, from the day we are born until the day we die we need large quantities of beneficial bacteria within us. Unfortunately, in this world, it is much easier to kill these bacteria than to keep them in residence. This is due to a number of reasons including the intake of refined foods, chlorinated water and quick-fix antibiotic medications.

Earlier, I have noted that the first step to understanding your digestive system is to know what it's made up of. As we eat, food passes from our mouth through our esophagus and down into our stomach and intestines. There, under normal conditions, enzymes break down food into nutrients, which our body absorbs and uses for energy. (The remaining, unused portion is passed through to our large intestine and colon where it is excreted from our body.)

A variety of bacteria and other microorganisms, which make up what is called the intestinal microflora help keep the digestive system running optimally by efficiently digesting food and processing waste. These bacteria can be classi-

fied as "good" and "bad" bacteria, both of which are essential for keeping the intestinal microflora in equilibrium. Whereas the bad bacteria have the potential to cause disease and illness, the good bacteria counteract by fighting off disease and illness, helping us stay healthy. Everything is in balance, what is known as "dynamic homeostasis."

Our friendly bacterial cultures (probiotics) are a major component of the interior of our digestive systems. Probiotics are intimately involved in nearly every process including detoxifying, digestion, absorption, even producing nutrients by themselves. Without a healthy balance of beneficial bacteria, the bad bacteria will take over, causing toxicity. If your GI tract is toxic, maldigestion and malabsorption of nutrients will occur. This can cause nutritional deficiencies or even overt symptoms of illness.

Many nutrients are dependent upon probiotic cultures for adequate digestion and proper utilization. Though we may get nutrients from a variety of sources, absorption of optimum amounts may depend in large part on the overall health of the intestines and their resident "guests." For example, our ability to absorb and utilize minerals such as calcium, zinc, iron, manganese, copper and phosphorus is very much dependent upon our bacterial populations. Proteins also require our bacterial friends in order to be properly broken down and digested. Many of the B complex vitamins also require a healthy population of beneficial bacteria in order to be properly utilized or even manufactured.

Dysbiosis or bacterial imbalances can be a significant factor in many health problems, in part because of poor nutrient assimilation. In the human large intestine, beneficial bifidobacteria synthesize vitamins that are slowly absorbed in the body. Bifidobacteria are known to produce thiamin, riboflavin, and vitamins B_6, B_{12} and K, Bifidobacteria can also synthesize amino acids for absorption in the gut. Adaptation of the gastrointestinal tract with bifidus enhances nitrogen retention, while resulting in a 400 percent increase of vitamin B_6 content in stools.

This is really important. We now know that many of the problems associated with aging such as senility, depression, loss of energy and even atherosclerosis are sometimes caused by low levels of the B vitamins or other key nutrients. And without beneficial bacteria to help produce these important nutrients, our bodies simply can't manufacture enough of these vitamins. That's why reinvigorating populations of friendly vitamin B complex-producing bacte-

ria is so beneficial to all persons, but especially the elderly.

Even aching joints and bones may be helped. That is because lactobacilli help the body to produce vitamin K. This vitamin helps to build strong bones. A lack of vitamin K may predispose the body to osteoporosis-related bone loss. Improved digestion—this alone is a good reason to supplement your daily diet with probiotics. There are a lot of other good reasons, too.

Without a steady supply of probiotics to replenish the gut, we cannot continue to benefit from these intestinal flora.

Chapter
Three

INFLAMMATORY BOWEL DISEASE

I nflammatory Bowel Disease (IBD) refers to two chronic intestinal disorders: Crohn's disease and ulcerative colitis. These conditions affect between 2 to 6 percent of Americans, or an estimated 300,000 to 500,000 people.

The causes of Crohn's disease and ulcerative colitis are not yet well understood, but a leading theory suggests that some agent, perhaps a virus or bacterium, alters the body's immune response, triggering an inflammatory reaction in the intestinal wall. Many health professionals believe that this virus or bacterium is more likely to exert its disease-causing effect when the body's balance of friendly bacteria is upset.

The onset for both diseases peaks during young adulthood. An individual with either disease may suffer persistent abdominal pain, bowel sores, diarrhea, fever, intestinal bleeding, or weight loss (wasting disease).

If your doctor thinks you have either Crohn's disease or ulcerative colitis, a variety of procedures and tests such as endoscopy and barium GI studies are available to confirm disease.

Once diagnosed, treatment options may include medications, dietary changes, and sometimes surgery, to remove diseased bowels. Remission and cure is possible in either condition, but both may persist over an individual's lifetime. Restoration of the balance of friendly bacteria to the gastrointestinal tract often helps, and is essential to recovery.

Crohn's Disease

Crohn's disease primarily involves the small bowel and the proximal colon. It may cause the intestinal wall to thicken and cause narrowing of the bowel

channel, possibly blocking the intestinal tract. The result is abnormal membrane function, including nutrient malabsorption.

About 90 percent of patients with Crohn's disease experience frequent and progressive symptoms of abdominal pain, diarrhea, and weight loss. This can lead to extreme weight loss seen in other wasting conditions such as cancer and AIDS.

The most commonly used drugs to treat Crohn's are sulfasalazine, prednisolone, mesalamine, metronidazole, and azathioprine.

If a patient does not respond to oral medications, the doctor may recommend surgery. Although surgery relieves chronic symptoms, Crohn's disease often recurs at the location where the healthy parts of the bowel were rejoined. The length of time that a Crohn's patient is in remission is not predictable. Again, rebalancing the body's bacterial populations can help.

Increasing evidence points to an important role for inflammatory cytokines (messenger compounds) for the pathogenesis of Crohn's disease. One such cytokine, tumor necrosis factor alpha (TNF-alpha), plays a key role in the pathogenesis of intestinal inflammation in Crohn's disease. (One study showed that release of TNF-alpha by inflamed Crohn's disease tissues can be significantly reduced by *Lactobacillus casei* or *Lactobacillus bulgaricus* supplements, which is a tantalizing though preliminary result).

Ulcerative Colitis

Ulcerative colitis (UC) is an inflammatory disorder affecting the inner lining of the large intestine. The inflammation originates in the lower colon and spreads through the entire colon. Blood in the stool is the most common and distinct symptom of ulcerative colitis. As with Crohn's disease, doctors diagnose ulcerative colitis by conducting a complete physical exam and other procedures such as barium enema, endoscopy and intestinal biopsy.

Patients with mild or severe ulcerative colitis are initially treated with sulfasalazine. Steroids are usually added in high doses. Other experimental drugs to treat ulcerative colitis include budesonide, tixocortol pivalate enema, and beclomethasone dipropionate enema.

Despite new therapies, an estimated 20 to 25 percent of ulcerative colitis patients will need surgery. Surgery cures ulcerative colitis and most patients can go on to lead normal lives—except some may do so with a colostomy bag. I think it is so important that we first try natural healing pathways.

Probiotics & Inflammatory Bowel Diseases

Richard N. Fedorak, M.D., of the University of Alberta, discussed the latest research on probiotics in inflammatory bowel diseases (IBD) at a symposium during Digestive Disease Week 2000. He notes there are many strains of probiotics under study for IBD, including lactobacilli *(GG, acidophilus, and salivarius)*, *Bifidobaterium bifidum, Streptococcus thermophilus, Saccharomyces boulardii,* and *Escherichia coli* (not all *E. coli* are bad guys; surprisingly, there are also beneficial strains of this species).

Dr. Fedorak noted that to be effective in treating IBD, a probiotic bacteria should be of human origin; nonpathogenic (does not cause disease); resistant to acid in the upper gastrointestinal tract; capable of adhering to the epithelium (the lining of the intestine); able to produce substances that can destroy pathogenic (disease-causing) bacteria; and able to modulate the immune system.

"Should we expect all strains of probiotics to have the same effect?" asked Dr. Fedorak. "Probably not. They differ in how well they adhere to epithelium, how well they fight bacteria, and how they regulate the immune system. Lactobacilli are able to survive the upper GI tract much better than bifidobacteria, but bifidobacteria are better at destroying pathogenic bacteria. Lactobacilli also have a better profile when you look at immune regulation, so lactobacillii may be better probiotics for IBD."

Dr. Fedorak explained how IBD develops, and how probiotics may interfere with this process. Referring to both patients and physicians, "You're only going to feel comfortable using probiotics if you understand how they are working," he told his audience.

He notes IBD involves three components:

- An antigen, that is, a bacterium or bacterial product that passes through the epithelium.
- Defects in the permeability of the epithelium, possibly because of genetic susceptibility to these defects, allowing the antigen into the intestine.
- A dysregulated immune response that occurs in response to the antigen, also genetically controlled.

"In normal individuals, the antigen passes through the epithelium and sets up an inflammatory response to eliminate the initiating bacteria," Dr. Fedorak explains. Two types of T cells interact in the intestine, T-helper-1 (Th1) cells,

which produce inflammatory cytokines, such as TNF-alpha, and T-helper-2 (Th2) cells, which produce anti-inflammatory cytokines, such as interleukin-10 (IL-10). Th1 cells respond aggressively to invaders, while Th2 cells restore balance to the immune system in the intestine.

"In people with IBD, the immune system is unable to down-regulate this activated inflammation," he says. "The Th1 response gets out of hand. That inflammatory response causes injury to the epithelium, resulting in the tissue damage and symptoms that you see as IBD."

What are the mechanisms for probiotics in IBD? "Bacteria adhere to the lining of the colon like icing on a cake," says Dr. Fedorak. "Probiotics are able to negotiate through this layer of bacteria and layer themselves against the epithelial surface. They prevent bacteria from adhering to or crossing the epithelium."

Furthermore, Dr. Fedorak cited a study presented at DDW 2000, demonstrating that probiotics stimulate the immune system. Liam O'Mahony, Ph.D., and colleagues (at the National University of Ireland, Cork) investigated the effect of *Lactobacillus salivarius* on human cells in the laboratory. They found that this probiotic enhanced the ability of the epithelium to inhibit the production of inflammatory cytokines, such as TNF-alpha. *L. salivarius* was capable of spurring on the Th2 response, while suppressing the inflammatory Th1 response. "You have evidence from a number of laboratories that probiotics are able to fix this immune dysregulation," noted Dr. Fedorak.

"Another important aspect of probiotics is their antimicrobial activity," added Dr. Fedorak. "Probiotics produce a number of agents that destroy bacteria—well over 50 of these agents have been classified. This is particularly important when considering specific bacteria that may be stimulating or initiating the process in IBD."

What evidence is there that these agents will work in IBD? In animal models, Dr. Fedorak cited the findings of Levinus Dieleman, M.D., Ph.D., and colleagues at the University of North Carolina, Chapel Hill, who reported that treatment with lactobacillus prevented the relapse of colitis in rat models. This group also has shown that lactobacillus prevents and treats colitis in mice.

Dr. Fedorak cited evidence found in fecal and tissue samples of people with Crohn's. "There was reduced bifidobacteria in Crohn's and reduced lactobacillus in ulcerative colitis," he said. "The worse the disease, the lower the level of probiotics [in the gastrointestinal tract]. There is evidence that probiotics probably

play a role in patients with IBD and that giving back those probiotics may be effective in our treatment."

Dr. Fedorak cited five clinical trials that apply this laboratory evidence to the treatment of people with IBD:

◆ B.J. Rembacken, M.R.C.P., and colleagues from The General Infirmary at Leeds, UK, reported on a trial of a safe strain of *E. coli* in active ulcerative colitis in the August 21, 1999 *Lancet*. (Some strains like *E. coli* : h-0157 are highly toxic, but not all, some of which are common to a healthy gut.) They randomly assigned 116 patients to receive steroids and either *E. coli* or mesalamine. Three months later, 68 percent of the group on *E. coli* were in remission, compared with 75 percent of the mesalamine group. All patients were weaned off steroids, and those in remission were permitted to continue receiving *E. coli* or mesalamine (also known as 5-ASA) alone at half the dose. At 12 months, 67 percent of those receiving *E. coli* had relapsed, along with 73 percent of those receiving mesalamine. "The authors conclude that this probiotic was able to keep a similar number of patients in remission over one year as mesalamine," said Dr. Fedorak, noting that this conclusion should be viewed cautiously. "Patients were receiving low doses of 5-ASA, maybe lower than what you would normally administer to maintain remission, and the rate of relapse at one year was near placebo rates."

◆ Wolfgang Kruis, M.D., and colleagues at the University of Cologne, Germany, treated 120 patients whose ulcerative colitis was in remission with either *E. coli* or mesalamine, according to their report in the October 1997 issue of *Alimentary Pharmacology & Therapeutics*. After three months, 16 percent relapsed in the *E. coli group*, compared with 11 percent in the mesalamine group. "They conclude that *E. coli* is similar to this dose of mesalamine in preventing relapse," says Dr. Fedorak. "But this was a limited number of patients, who were only followed for a short time. Again, the dose of mesalamine (1.5 grams/day) was low for maintenance therapy."

◆ Alessandro Venturi, M.D., and colleagues at the University of Bologna, Italy, treated 20 patients, also with ulcerative colitis in remission, with VSL-3, a combination of four strains of lactobacilli, three bifidobacteria, and one strepto-

coccus, notes their report in the August 1999 issue of *Alimentary Pharmacology & Therapeutics.* "Perhaps this is a good idea, because these probiotic strains are working through different mechanisms," mused Dr. Fedorak. "If one doesn't survive, the other likely will." At 12 months, the rate of relapse was 25 percent, a level that would be expected with mesalamine. "Again, this was an open, unblinded trial [a study where participants know the drug under study, and there is no comparison to another drug or to placebo] of a small number of subjects; it needs to be expanded."

+ The lone trial of probiotics in Crohn's presented at DDW 2000 c a m e from Mario Guslandi, M.D., of S. Raffaele Hospital, Milan, Italy, who treated 32 patients with Crohn's of the ileum or colon in remission, with *S. boulardii* and mesalamine, or mesalamine alone. At six months, one of 16 patients in the *S. boulardii* group had relapsed, compared with six of 16 in the mesalamine group. "This is a tantalizing piece of evidence to suggest that this yeast may be effective in maintaining remission in Crohn's," noted Dr. Fedorak.

+ Paolo Gionchetti, M.D., Ph.D., and colleagues at the University of Bologna, reported findings on preventing pouchitis using the probiotic "cocktail" VSL-3, at a Distinguished Abstract Plenary Session during DDW. They administered this probiotic cocktail to 20 patients immediately after the pouch procedure, while 20 others received placebo. Relapse rates at 12 months were 10 percent in the group receiving probiotics, and 40 percent in those receiving placebo.

+ Gerald Friedman, M.D., and James George, M.D., of the Mount Sinai School of Medicine, New York, treated 10 patients with unresponsive pouchitis with *Lactobacillus GG.* All had complete remission of symptoms and damage as found on endoscopy.

"These trials show promise," said Dr. Fedorak. "What we can take away from them is that probiotics are safe, with some side effects occurring in people who are immunosuppressed. In the May 2004 issue of *Gastroenterology*, we learn, Crohn's disease, ulcerative colitis, and pouchitis are caused by overly aggressive immune responses to a subset of commensal (nonpathogenic) enteric bacteria

in genetically predisposed individuals. Clinical and experimental studies suggest that the relative balance of aggressive and protective bacterial species is altered in these disorders. Antibiotics can selectively decrease tissue invasion and eliminate aggressive bacterial species or globally decrease luminal and mucosal bacterial concentrations, depending on their spectrum of activity. Alternatively, administration of beneficial bacterial species (probiotics), poorly absorbed dietary oligosaccharides (prebiotics), or combined probiotics and prebiotics (synbiotics) can restore a predominance of beneficial lactobacillus and bifidobacterium species. Current clinical trials do not fulfill evidence-based criteria for using these agents in inflammatory bowel diseases (IBD), but multiple non-rigorous studies and widespread clinical experience suggest that metronidazole and/or ciprofloxacin can treat Crohn's colitis and ileocolitis (but not isolated ileal disease) perianal fistulae, and pouchitis, whereas selected probiotic preparations prevent relapse of quiescent ulcerative colitis and relapsing pouchitis. These physiologic approaches offer considerable promise for treating IBD… These agents likely will become an integral component of treating IBD in combination with traditional anti-inflammatory and immunosuppressive agents." Many more studies show promise for colitis, too.

How to Use Probiotics for Inflammatory Bowel Diseases

It's really all very preliminary so be sure to work closely with a knowledgeable health professional familiar in treating these conditions. Taking a standard probiotic or the more exotic strains mentioned in these reports is often beneficial, but do work with a health professional.

I think it is always important to try to duplicate materials and dosages used in clinical studies if you are after a certain curative effect. Although, we also find many instances in which similar but not identical strains (say, two different patented strains of lactobacillus) do equally well, or about as well, at managing the same tasks.

Do not discontinue medications unless advised to do so by your physician.

Chapter
Four

~~~

## IRRITABLE BOWEL SYNDROME

I rritable Bowel Syndrome (IBS) is a common functional disorder of the intestines estimated to affect five million Americans. The cause of IBS is not yet known. Doctors refer to IBS as a functional disorder because there is no sign of disease when the colon is examined. But functional, in this case, means "dysfunctional," as one doctor notes.

Doctors believe that people with IBS experience abnormal patterns of colonic movement and absorption capabilities. The IBS colon is highly sensitive, overreacting to any stimuli such as gas, stress, or eating high-fat or fiber-rich foods.

Patients with IBS often experience alternating bouts of constipation and diarrhea. Although abdominal pain and cramps are among the most common IBS symptoms, pain or discomfort alone is not sufficient to make the diagnosis. However, when a bowel movement or the passage of gas temporarily relieves pain and cramps, a doctor may suspect IBS and begin therapy.

IBS is frequently diagnosed after doctors exclude more serious intestinal diseases through a detailed medical history and complete physical examination. There is no standard way of treating IBS, but multiple drugs are often used. In addition, antidepressants and psychotherapy are frequently part of the program.

Of critical importance is restoration of friendly bacteria to the gut and appropriate lifestyle and dietary changes.

Probiotics have been used with apparent success for several gut disorders, so it is not surprising that they have been tried in the treatment of irritable bowel syndrome. However, the pathogenesis of this disease is unknown, and opinions about how probiotics might work are speculative.

"Nevertheless, two small trials suggest they might benefit patients with IBS, particularly those suffering from pain and bloating," notes Dr. G.W.Thompson of the University of Ottawa, Canada."This possibility deserves further study."

"Promising results" are being reported in patients not only with inflammatory bowel disease but also irritable bowel syndrome, says researcher S.L. Gorbach, of Tufts University School of Medicine, Boston.

At the Department of Gastroenterology, M.Curie Regional Hospital, Szczecin, Poland, researchers assessed the efficacy of *Lactobacillus plantarum* 299V (LP299V) in patients with IBS. Forty patients were randomized to receive either LP299V in liquid suspension (20 patients) or placebo (20 patients) over a period of 4 weeks. Additionally, patients assessed their symptoms by applying a scoring system. All patients treated with LP299V reported resolution of their abdominal pain as compared to 11 patients from a placebo group. There was also a trend towards normalization of stool frequency in constipated patients in six out of 10 patients treated with LP299V compared with two out of 11 treated with placebo. With regards to all IBS symptoms, an improvement was noted in 95 percent of patients in the LP299V group versus 15 percent in the placebo group.

Meanwhile, researchers from the Department of Internal Medicine and Gastroenterology, Bellana Hospital, University of Bologna, Italy, report in the September 2002 issue of *Digestive & Liver Diseases*, that their open noncontrolled trial was the first showing a clinical improvement related to changes in the composition of the fecal bacterial flora and in fecal biochemistry and, remarkably, in elimination, to be induced by administration of probiotics, in patients with functional diarrhea, often a symptom of IBS.

The idea that unbalanced bacterial populations can play a role in causing IBS is a new idea but one that seems solid. "This is really exciting because it points to the cause of the disease," says Mark Pimentel, M.D., assistant director of the gastrointestinal motility program at Cedars-Sinai Medical Center, Beverly Hills, California and co-author of a recent study in *The American Journal of Gastroenterology* that linked pathogenic bacterial strains to IBS. "Treatments for irritable bowel syndrome to this point have been directed at symptoms, not any cause." Many other studies now support the bacterial-IBS link.

Thus, we see that probiotics seem to have a beneficial effect in patients with IBS. Of course, further studies on larger numbers of patients and with longer

duration of therapy are required in order to establish the place of probiotics in the treatment of IBS

**How to Use Probiotics for Irritable Bowel Syndrome**

This is really a case where I believe a number of different lactobacillus strains will help. Certainly, *Lactobacillus plantarum* 299V (LP299V) appears to be one of the more promising strains, and products containing this bacterium should be available at health food and drug stores. Other lactobacillus supplements may also benefit.

Do not discontinue medications unless advised to do so by your physician.

# Chapter
## Five

## PEPTIC ULCER

**H**eliobacter pylori (H. pylori) is a spiral-shaped bacterium that makes its home in the gastric mucus layer, or the cell lining, of the human stomach. As the bacteria colonize the stomach, the lining is weakened and becomes vulnerable to irritation from natural stomach acids. The result is an ulcer. In fact, *H. pylori* causes about nine out of 10 duodenal ulcers, and more than eight out of 10 gastric ulcers. There is also now a clear link between this bacterium and higher incidence of gastric cancer. An estimated 2.5 million new *H. pylori* infections occur each year in the United States.

---

*Every year 4 million people report that they miss approximately 6 days from work because of their ulcers.*

---

Peptic ulcer disease, estimated to affect 4.5 million people in the United States, is a chronic inflammation of the stomach and duodenum. Peptic ulcer is responsible for substantial human suffering and a large economic burden. Every year 4 million people report that they miss approximately 6 days from work because of their ulcers.

Peptic ulcers result from the breakdown of the lining of the stomach and duodenum caused by *H. pylori*, which burrows in between the cells and weakens the gastrointestinal tissues. One type of ulcer occurs in the stomach, the other in the duodenum, the first part of the small intestine. Duodenal ulcers are much

more common than stomach ulcers, which have a greater risk of malignancy.

There are no specific symptoms of gastric and duodenal ulcers. However, upper abdominal pain and nausea are the most common symptoms of peptic ulcer disease. Ulcer pains usually occur an hour or two after meals, or in the early morning hours and abate after food or antacids have been eaten. Definitive diagnosis of peptic ulcer disease requires endoscopy, which also allows a doctor to obtain biopsy samples, if needed. The FDA's 1996 approval of a safe, effective breath test makes noninvasive diagnosis of ulcers possible.

Many new therapeutic strategies are being studied to improve the eradication of *H. pylori*. The use of probiotics in the field of *H. pylori* infection has become an important adjunct treatment to lessen side effects of prescribed treatment, especially as antibiotics not only eradicate *H. pylori*, but also eliminate many beneficial bacterial strains from the body.

Results from laboratory studies and from clinical trials confirm that a quality probiotic supplement will dramatically reduce the rate of side effects. In a recent study, researchers found that persons who received a combination of antibiotic therapy with probiotics had "a significantly lower incidence of diarrhea and taste disturbance" than persons receiving only antibiotics. Additional studies confirm this finding. In experimental research, probiotics not only inhibit *H. pylori* but also help to prevent ulcers caused by use of painkiller medications.

Furthermore, probiotics protect against the downside of antibiotic regimens used to kill off offending bacteria such as *H. pylori*. While you're killing the harmful bacteria, you want to keep reestablishing the friendly bacteria. This can be done both during and after the drug therapy.

In addition, there are some findings that probiotics could help to actually eradicate the *H. pylori* pathogen. In a recent study, Yasmin et al (2002) reported the ability of DDS-1 *L.acidophilus* in inhibiting *H. pylori*. In a 2002 report in the *Journal of Applied Microbiology*, researchers at the Department of Head & Neck/Thoracic Medical Oncology, MD Anderson Cancer Center, Houston, Texas, evaluated a traditional yogurt used as folk medicine for its ability to kill *Heliobacter pylori* in vitro. Two yeasts and several strains of lactobacilli were isolated from the yogurt, and both the yeast and the lactobacilli independently showed antibacterial activity against *H. pylori*. The yeast and lactobacilli found in the yogurt form a hardy symbiotic culture, the researchers said. "The organisms secrete soluble fac-

tors capable of killing *H.pylori*, and these factors may include some organic byproducts of fermentation...These yogurt derived food preparations could become simple and inexpensive therapies to suppress *H.pylori* infections in endemic countries." Other studies have not found such benefits. But we do know that probiotics assuredly help to alleviate symptoms of intensive therapy with antibiotic medications your doctor normally prescribes.

If you are using painkillers that invariably are linked to gastric bleeding and ulcers, some preliminary experimental work suggests this might be another good reason to choose a quality probiotic supplement.

---

*These yogurt derived food preparations could become simple and inexpensive therapies to suppress H.pylori infections in endemic countries.*

---

**How To Use Probiotics for Peptic Ulcers**

Be sure to follow the recommended label instructions and work with your physician to determine the optimal dosage. Do not discontinue medications unless advised to do so by your physician. Especially after the cessation of the antibiotics, probiotic supplements are recommended.

# Chapter
## Six

———— ❧ ————

## PROBIOTICS AND INDIGESTION

**M**ild, occasional indigestion is generally transient and self-limiting without the need of medical care. But when indigestion becomes a chronic problem that accompanies practically every meal, then you have a serious problem. Often overlooked by the medical profession is that a significant cause of indigestion and even irritable bowel syndrome is *not* necessarily oversecretion of hydrochloric acid but the result of inability to digest and assimilate food—particularly when we have experienced constipation, diarrhea, and mineral depletion on a long-term basis.

This disorder is often the result of our old friend, dysbiosis. Lactobacilli are indispensable to healthy digestion because of their ability to produce digestive enzymes including proteases, beta-galactosidase, and lipases that digest protein, sugar and fats, respectively. This in turn produces acids that support a healthy pH and enhance nutrient assimilation.

Another key benefit is that beneficial bacterial populations stimulate peristalsis, the wave-like motion of the smooth muscles of the digestive system as they expand and contract and move along food that is being digested. Very often, poor peristalsis is the result of inadequate fiber and fluids. Fructooligosaccharides (FOS) aids peristalsis both as a bulking agent and by liquefying the contents of the colon. See Appendix D.

The large intestine is an anaerobic environment and home to the digestive system's highest concentration of bacteria with 100 billion to 1,000 billion microorganisms per tablespoon. When food has reached the large intestine, it is very loose and watery. Its nutrients have been absorbed, and the body must now

transport out the waste. To do so, this liquid watery mass must be reconverted into a solid, then excreted. It is important that this process occurs quickly, otherwise the wastes putrefy and produce toxic, often carcinogenic, substances that can cause chronic disease including cancer. The large intestine's populations of beneficial bacteria help to accelerate this process as well as offer protection against toxicity. They stimulate peristalsis and prevent conversion of toxins into carcinogens. Their healthy population prevents pathogenic bacteria from taking up residence.

And if you are lactose intolerant, here's another bonus. Probiotics' beneficial effect on friendly bacterial populations may help alleviate lactose intolerance caused by deficiency of the lactase enzyme. That is because friendly bacterial strains like *Lactobacillus acidophilus* produce enormous quantities of lactase enzymes that can help to digest the milk sugar, lactose more fully. This in turn should help to relieve the bad breath, bloating, gas formation and stomach cramps associated with lactose intolerance.

So be sure you give lactose intolerant kids probiotics. Probiotics can also help during pregnancy to reduce lactose intolerance in children. Consult your doctor.

# Chapter
## Seven

————⌒————

## LEAKY GUT SYNDROME

I f you use painkillers, imbibe alcohol or are concerned, as we recommend you should be, with runaway bodily inflammation, then caring for your gastrointestinal health with probiotics should be considered as part of your health promotion program. In fact, if you are taking a baby aspirin a day or using other non-steroidal anti-inflammatory drugs (NSAIDs), this information is critical.

### Leaky Gut Syndrome — Serious & Widespread

What on earth is a leaky gut? And why should we be concerned with this condition? Well, leaky gut is a serious condition and probably far more widespread than we might realize; even if you are clinically healthy today and don't know you have leaky gut, it could well put you at risk for serious disease.

"A major task of the intestine is to form a defensive barrier to prevent absorption of damaging substances from the external environment," says Daniel Hollander, M.D., of the Harbor-UCLA Research and Education Institute. Dr. Hollander is one of the nation's leading experts on inflammatory bowel disease.

This protective function of the intestinal mucosa is called permeability. Clinicians use inert, nonmetabolized sugars such as mannitol, rhamnose, or lactulose to measure the permeability barrier or the degree of leakiness of the intestinal mucosa.

Ample evidence indicates that permeability is increased in most patients with Crohn's disease and in 10 to 20 percent of their clinically healthy relatives. Permeability is also increased in celiac disease and by trauma, burns, and use of non-steroidal anti-inflammatory drugs (NSAIDs) such as aspirin and ibuprofen.

Alcoholics and people who imbibe would also do well to be concerned about leaky gut. Thirty percent of alcoholics develop cirrhosis, and new research suggests that the development of alcohol-induced liver injury is caused in part by a leaky gut, say researchers at the Department of Medicine (Division of Gastroenterology), Loyola University Medical School, Maywood, Illinois.

Animal studies have shown that gut-derived endotoxin is a critical factor in causing cirrhosis. Increased intestinal permeability has been shown to cause endotoxemia, and it is now believed increased gastrointestinal permeability (leaky gut) contributes to alcoholic liver disease.

"Because only the alcoholics with chronic liver disease had increased intestinal permeability, we conclude that a 'leaky' gut may be a necessary cofactor for the development of chronic liver injury in heavy drinkers.

## Leaky Gut—Inflammation Connection

Many of the pathogens that make us sick enter the body through the food we eat. This means that an individual with leaky gut syndrome is much more vulnerable to infection than someone with a healthy gastrointestinal tract.

The activation of immune cells within the huge surface area of the gut lining can cause a systemic inflammatory response—and overall bodily inflammation, we now are learning, is a key to many different disease states, including heart disease, cancer, arthritis, and diabetes. The passage of bacteria and toxins through leaky gut mucosa may amplify or perpetuate this systemic inflammation.

Inflammation causes damage to the tissue, resulting in excess permeability and unusually large spaces between the cells of the mucosal lining, which allows bacteria, viruses, fungi and other potentially toxic materials to enter the bloodstream. The widened spaces can also allow undigested food particles to "leak" through the intestinal lining. This could pose a serious health risk since these particles may be considered "foreign" by the body and the immune system may try to destroy them.

Thus, by this logic, leaky gut can be linked with a whole host of chronic diseases. It is not the only cause, but in many people, leaky gut isn't detected, and they don't know that they should be healing the gastrointestinal lining with probiotics and other nutritional supplements.

## Benefits from a Healthy Gut Lining

There are many benefits that accrue to people who free themselves from leaky gut. Allergies and food sensitivities are markedly reduced. Risk for heart disease, cancer, diabetes, and arthritis also decrease—along with overall bodily inflammation.

There are even nutritional benefits. Repairing the intestinal damage caused by leaky gut syndrome can improve nutrient uptake. Leaky gut syndrome results in significant mineral deficiencies because the same inflammatory process that injures the mucosal lining damages carrier proteins. These carrier proteins are the means by which many of the essential minerals are absorbed.

In the September 2001 issue of *Gastroenterology*, researchers from the Division of Gastroenterology, University of Alberta, Edmonton, Canada, found that the probiotic compound VSL-3 improved gastrointestinal epithelial barrier function and resistance to salmonella invasion Perhaps this effect is due to effects on mucin secretion or probiotic immunomodulation of gut-associated lymphoid tissue.

And in *Nutrition Today,* researchers state, "As a result of intestinal inflammation, a greater amount of antigens may traverse the mucosal barrier, thus becoming an important risk factor for the development of allergic disorders." They note that lactobacilli and other probiotic microorganisms "help reinforce the barrier effect in the gut. The results of the studies in this article show that the capabilities of such probiotics may introduce immunotherapy as a new approach for the early management of allergic diseases."

Other researchers state, "Studies have shown probiotic bacteria have potential in the treatment of clinical conditions with altered gut mucosal barrier functions."

## Quick Check: At Risk for Leaky Gut?

Leaky gut syndrome is a very common (often undiagnosed) condition in which the lining of the small intestine becomes inflamed. Many different things, including the following, can cause this inflammation:

- Alcohol and/or drinks containing caffeine.
- Overuse of antibiotics resulting in destruction of the "good" bacteria in the intestines.
- Foods contaminated by certain bacteria or parasites.

- Corticosteroids, such as prednisone, and/or non-steroidal anti-inflammatory drugs like aspirin or ibuprofen.
- Consumption of large quantities of highly refined carbohydrates, (sugar and processed flour).

Under any of these conditions, you should consider using probiotic supplements containing *Lactobacillus acidophilus* and bifidus cultures. Be sure to take your doctor's advice before discontinuing any prescribed medications.

Chapter
Eight

## LACTOSE (MILK SUGAR) INTOLERANCE

An estimated 30 million Americans experience lactose intolerance. The digestive enzyme, lactase, needed to digest lactose is either not in their gastrointestinal tract or simply not functioning as well as it should. Symptoms include bloating, gas, stomach cramps, diarrhea and other intestinal discomforts after consuming dairy products.

Probiotics are helpful for those suffering from the above-mentioned symptoms. These beneficial bacteria do not necessarily have to be consumed each and every time dairy products are consumed but it should be taken regularly.

Reporting in the February 2001 issue of the *American Journal of Clinical Nutrition*, researchers from the Institute of Physiology and Biochemistry of Nutrition, Federal Dairy Research Center, Kiel, Germany, note that, "Yogurt and other conventional starter cultures and probiotic bacteria in fermented and unfermented milk products improve lactose digestion and eliminate symptoms of intolerance in lactose maldigesters."

These beneficial effects are due to microbial beta-galactosidase enzymes in the fermented milk products, delayed gastrointestinal transit, positive effects on intestinal functions and colonic microflora, and reduced sensitivity to symptoms. They continue, "Probiotic bacteria, which by definition target the colon, normally promote lactose digestion in the small intestine less efficiently than do yogurt cultures. They may, however, alleviate clinical symptoms brought about by undigested lactose or other reasons."

**How to Use Probiotics for Lactose Intolerance**

Be sure to choose a quality probiotic supplement containing lactobacillus and bifidus cultures. Be sure to follow the recommended label instructions or work with your physician to determine the optimal dosage. Consuming fermented dairy foods such as yogurt will also help to alleviate lactose intolerance, as will taking digestive enzymes containing lactase. Remember, all lactose intolerance problems cannot be corrected by probiotics. So consult your doctor for this milk allergy problem.

Chapter
Nine

# CONSTIPATION

A ccording to the 1991 National Health Interview Survey, about 4 1/2 million people in the United States say they are constipated most or all of the time. Those reporting constipation most often are women, children, and adults age 65 and over. Pregnant women also complain of constipation, and it is a common problem following childbirth or surgery.

Constipation is the most common gastrointestinal complaint in the United States, resulting in about two million annual visits to the doctor. However, most people treat themselves without seeking medical help, as is evident from the $725 million Americans spend on laxatives each year.

## Common Causes of Constipation

- Not enough fiber in diet
- Not enough liquid consumption
- Lack of exercise
- Medications
- Irritable bowel syndrome
- Changes in life or routine such as pregnancy, older age, and travel
- Abuse of laxatives
- Ignoring the urge to have a bowel movement
- Specific diseases such as multiple sclerosis and lupus
- Problems with the colon and rectum
- Problems with intestinal function (Chronic idiopathic constipation).

Probiotics can help constipation. In a study, 305 of 356 cases of chronic constipation showed improvement with *Lactobacillus acidophilus* supplementation.

Successfully bolstering lactobacillus populations was followed by relief of symptoms in constipation resulting from a variety of triggering conditions such as mucous colitis, irritable colon, and idiopathic ulcerative colitis.

Additional studies dating to the 1920s and 1930s also bolster the use of probiotics for boosting populations of friendly bacteria and reducing constipation.

Most recently, researchers at the Department of Biochemistry and Food Chemistry, University of Turku, Finland, studied the effect of probiotics on 28 constipated elderly volunteers. The study volunteers were divided into three groups: one group receiving juice; one receiving juice supplemented with *Lactobacillus reuteri*; and one receiving juice supplemented with *Lactobacillus rhamnosus* and *Propionibacterium freudenreichii*.

During the first four weeks all subjects consumed unsupplemented juice. In the subsequent four weeks, the subjects received their designated juice. During the last three weeks, all subjects again received unsupplemented juice.

Persons receiving the *L. rhamnosus/P. freudenreichii*-supplemented juice exhibited a twenty-four percent increase in bowel movement frequency. "Some relief from constipation may be observed with the combination of *L. rhamnosus/P. freudenreichii*," say the researchers.

In short, diarrhea, constipation, and loss of beneficial bacterial populations as a side-effect of antibiotic use can all be overcome with the use of probiotics.

## How to Use Probiotics for Constipation

Be sure to choose a quality probiotic supplement containing lactobacillus and bifidus cultures. Be sure to follow the recommended label instructions and work with your physician to determine the optimal dosage. Do not discontinue medications unless advised to do so by your physician.

# Chapter Ten

## IMMUNE FUNCTION

C an you read Egyptian Hieroglyphics? If so, you would learn some fascinating secrets of ancient Egyptian medicine. In *Science and Secrets of Early Medicine*—which makes for fascinating reading for all persons interested in ancient medical practices—we learn that many ancient Egyptian prescriptions included droppings from the common fly and pelicans, excrement from lizards and the Nile crocodile, even dung of the gazelle, as well as human urine. Even now, traveling into the 20th Century, we find North African nomads often treat dysentery with bits of fresh horse or camel dung.

What do we make of this dung therapy? Were the ancient Egyptians and their modern descendents out of their minds?

*Not at all!*

As explained in *Science and Secrets of Early Medicine*, we now know "that bacteria living in the human body release their excretory products into the faeces and urine, which therefore are rich in antibiotic substances."

Well, today, we have a more palatable alternative: probiotics.

Very recently, researchers from the University of Paris dramatically demonstrated the impact that a healthy population of friendly flora in the body have on immunity in a report in the *American Journal of Clinical Nutrition*. What's more, they found the effect to be sustained for some time even after supplementation was discontinued.

In this study, 28 healthy volunteers were told to drink milk with or without the two major friendly bacteria in the gut, *Lactobacillus acidophilus* or *Bifidobacterium bifidum*. Three weeks later, the scientists

took blood samples from the volunteers and intentionally contaminated these samples with disease-causing *E. Coli*, that causes severe vomiting, nausea, kidney failure and death, particularly in children and the elderly. The percentage of white blood cells known as phagocytes (which ingest bacteria and cell debris) that attacked and gobbled up *E. Coli* was 40 to 80 percent higher in the persons receiving the friendly bacteria than it was in those drinking plain milk. Six weeks after the volunteers ceased drinking their milk with friendly bacteria, their phagocyte activity remained far higher than when they began the study.

"While most commonly considered for digestive function, probiotics play a crucial role in the immune activity of the human body," says health writer Heather Granato. Friendly bacteria help the body to subdue many bacterial and other enemies including *Candida albicans, Escherichia coli, Salmonella typhosa, Staphylococcus aureus,* shigella, *Costridium difficile, Bacillus cereus, Streptococcus faecalis,* and *Campylobacter jejuni.* They do so via their natural secretions which act as natural antibiotics (especially when our levels of the B vitamins folic acid and riboflavin are adequate) and by population displacement of unfriendly bacteria.

Thus, they really rev up our immune function.

Bifidobacteria are the most predominating intestinal flora in infants. Children with high numbers of bifidobacteria resist enteric infections very effectively. In fact, the feeding of bifidobacteria-containing dairy products has been used to treat these infections in Japanese children with success.

---

## *...infants given formula tend to be overrun by bad bacteria.*

---

This information is critical for adults and children alike, by the way. For example, we know that breast-fed babies get fewer infections. When a baby is born, the intestines are virtually sterile and free of microorganisms. Then, within days a land grab ensues, the likes of which haven't been seen since the days of the Wild West. Friendly and unfriendly bacteria alike rush in to take over the empty land of the child's intestine. By the fourth to seventh day, the intestines of breast-fed babies generally have enough friendly bifidobacteria

from their mother's milk to keep the bad guys at bay. Unfortunately, infant formula cannot provide the same beneficial bacteria. Thus, infants given formula tend to be overrun by bad bacteria.

This is similar to what happens with antibiotics, too. Only in this case, antibiotics wipe out populations of friendly bacterial inhabitants of portions of the intestines to set up the land grab. In this case, taking prebiotics and probiotics can position the good bacteria on our side to form an impenetrable barrier to keep out the bad bacteria.

We also know that, generally, compared to healthy children and adults, the elderly have very low counts of bifidobacteria. Yet, as bifidobacteria numbers drop, there is a corresponding increase in the numbers of toxic species of *Clostridium perfringens* detected in the elderly. This can cause all sorts of problems, as *C. perfringens* produces a host of undesirable substances including toxins and volatile amines that can be potentially cancer causing. Yet adults who bolster their population of friendly bacteria have demonstrated substantial decreases in clostridium counts as well as an increase in bifidobacterium counts. This translates into better health as we age.

Beneficial flora produce acidophiline bactericidins, defensins, cationic proteins and lactoferrin, all of which work to destroy other pathogenic or harmful bacteria that compete for a hold in the body.

Boosting the body's populations of friendly bacteria boosts its anti-infectious properties. Medical journalist Dr. Morton Walker reports in his book *Secrets of Long Life* that *Lactobacillus acidophilus* contains several powerful anti-microbial compounds such as acidolin, acidophyllin, acidolphin, lactocidin, and bacteriocin. These germ-fighting bacterial compounds have been proven to eradicate *E. coli*, listeria, *Streptococci staphylococci*, *Candida albicans*, herpes and flu viruses. For example, in a laboratory study (*in vitro*), acidophyllin, one of the antibacterial components of acidophilus, caused a 50 percent inhibition in growth of 27 different types of bacterial species including 23 common pathogens.

Probiotics have a well-deserved reputation not only for favorably altering the intestinal microflora balance but also for inhibiting populations of harmful bacteria, boosting immune function, and supporting resistance to and recovery from infections.

In a very recent study, for example, supplements containing lactobaccilli bacteria lessened the duration of winter infections (gastrointestinal and respiratory) by 20 percent in elderly people.

You will enjoy greater overall resistance to pathogens that can wreak health havoc, as this most recent study shows, and your ability to recover will also be improved.

Research reviews from the University of Turku, Finland, explored the role of probiotics in general human disease and, specifically, in immune function.

Probiotics work to reinforce the lines of gut defense-exclusion of pathogens, elimination of toxins and regulation of immune compounds. The gastrointestinal tract is an integral part of the innate immune system, functioning as a barrier against antigens from food and microorganisms. The researchers noted many probiotic effects are mediated through immune regulation, particularly through balanced control of cytokines, and that differences exist in the effects of different probiotics.

Probiotic bacteria, for example, signal the immune system through innate cell surface pattern receptors or by activating lymphoid cells (as found in the Peyer's patches). In a clinical study of 30 healthy volunteers given *Lactobacillus GG*, *Lactococcus lactis* or placebo and then challenged with a *Salmonella typhi* oral vaccine, those given *Lactobacillus GG* had a greater increase in specific immunoglobulin-A (IgA). Researchers concluded the immunomodulatory effect of probiotics may, therefore, be strain-dependent.

But, based on other research, I doubt that one strain holds all that much of a greater edge. For example, studies on bifidobacterium have shown effects similar to the above results with completely different friendly species. Researchers from Kangwon National University, Republic of Korea, noted *B. bifidum* alone significantly induced total IgA and IgM synthesis by lymph nodes and Peyer patch cells. The researchers also found *B. bifidum* increased the number of Ig secreting cells but did not induce antibody responses. This is supported by a clinical study conducted at Massey University in Palmerston North, New Zealand. Thirty healthy elderly volunteers were given milk supplemented with *Bifidobacterium lactis* HN019 in a typical or low dose. Both doses showed similar effectiveness in increasing proportions of total, helper and activated T lymphocytes and NK cells.

**How to Use Probiotics for Healthy Immune Function**

Be sure to choose a quality probiotic supplement containing lactobacillus and bifidus cultures and take it daily. Be sure to follow the recommended label instructions and work with your physician to determine the optimal dosage. Do not discontinue medications unless advised to do so by your physician. A healthy diet and exercise will also boost immune function.

For children, mix probiotics with their baby food, juice or cereal.

# Chapter
# Eleven

## ALLERGIES

G astrointestinal microflora are an important part of the gut defense barrier, which is made up of mucosal lining. Lactobacillus promotes localized protein-specific immune responses (scientifically referred to as Immunoglobulin A-mediated antigen specific immune response). Probiotic bacteria may even promote protective barrier mechanisms in patients with atopic dermatitis and food allergies (see below). By alleviating intestinal inflammation, lactobacilli may also act as a useful tool in the management of food allergies.

Although we don't have a lot of evidence on beneficial bacteria and children's allergies, in one study on childhood food allergies, it was found that a deficiency of *Lactobacillus acidophilus* and bifidobacteria combined with overgrowth of enterobacteriaceae was common to all cases of a group of children. Thus, probiotics could prove very helpful. This is backed by anecdotal clinical experience where we see that children with food allergies tend to improve markedly once we get them on a daily dose of probiotics (usually as part of their cereal or juice).

Giving soon-to-be mothers and newborns doses of "good" bacteria may help prevent childhood allergies up to age four, continuing research in the *Lancet* and as reports by Reuters suggest. The findings, a follow-up from a study that initially looked at allergies in newborns up to age two, may offer evidence that harmless bacteria can train infants' immune systems to resist allergic reactions.

In the ongoing study, researchers in Finland used a lactobacillus species to try to prevent allergy development in at-risk infants.

In the original study, Dr. Marko Kalliomaki and colleagues at Turku University

Hospital, Finland, gave a group of pregnant women either probiotic capsules or placebo capsules every day for a few weeks before their due dates. For six months after delivery, women who breast-fed continued on the probiotics or placebo, while bottle-fed infants were given probiotics or placebo directly. All of the babies were considered to be at high risk of developing allergies because a parent or sibling was affected.

Dr. Kalliomaki's team originally published results of the study when the children were two years old. Now, the researchers report that the youngsters in the probiotic supplement group were less likely at age four to have developed an allergic skin condition called atopic eczema.

"The main finding is that administration of probiotics (shortly before and after birth) may prevent the development of atopic eczema during the first four years of life in high-risk children," Dr. Kalliomaki told Reuters Health. Children at high risk, he said, are those whose mothers, fathers or older siblings have asthma, atopic eczema or allergic rhinitis.

"The new finding is that the preventive potential of *Lactobaccilus GG* may extend beyond infancy ... to the age of four years," the researcher added.

By the age of four years, 25 of 54 children in the placebo group had developed allergic eczema, a condition in which the skin becomes irritated, red and itchy. But just 14 of the 53 children who had received probiotics developed the skin condition, which was a 43 percent reduction, according to the report.

In another report from Finland, researchers from the Department of Biochemistry and Food Chemistry, University of Turku, assessed the fecal microflora of 10 healthy infants and 27 infants with atopic eczema during breast-feeding and after weaning. The atopic infants had far lower bifidobacteria counts.

### How to Use Probiotics for Allergies

Be sure to choose a quality probiotic supplement containing lactobacillus and bifidus cultures and it take daily. Be sure to follow the recommended label instructions and work with your physician to determine the optimal dosage. Do not discontinue medications unless advised to do so by your physician.

For children, mix the probiotic supplement with baby food, juice or cereal.

# Chapter
## Twelve

———— ❧ ————

## WOMEN'S HEALTH

A 1996 Diflucan pharmaceutical survey shows 85 percent of all teenage and adult females in the United States are plagued with vaginitis and its itchy, messy, discharge at least once in their lives. Many of these women will continue to suffer with vaginal infections for a period of years. Although prescription drugs and over-the-counter preparations are on the market today to treat vaginitis, these products provide symptomatic relief, but seldom get to the cause of the problem. When prescription treatment ends for vaginitis, the organisms involved often develop drug resistance. This can bring a resurgence of germ colonies with greater strength than before treatment started.

Any number of situations can promote vaginitis: radiation therapy, hormonal changes, excessive use of antibiotics, characteristics of pregnancy and menopause, vitamin B deficiency, excessive douching, or poor hygiene in the vaginal area. Even intestinal worms, oral contraceptives, or deodorant sprays can cause vaginitis. Atrophic vaginitis is found in postmenopausal women and develops due to hormonal drops of estrogen in the vaginal canal.

Antibiotic usage is the "usual suspect" when vaginitis is the diagnosis in nonpregnant women under 45. When colonies of friendly bacteria are present in sufficient numbers within the vaginal lining, conditions are normal and balanced. However, when antibiotics deplete beneficial bacteria, yeast organisms have the opportunity to overgrow and produce inflammation because they are not killed off by antibiotics. Sugar consumption, either natural or refined, only feeds the fire of vaginal yeast infection. All too soon, yeast colonies will dominate in the vagina.

But do not despair. A growing number of medical doctors have found an effective, natural way to help their female patients get faster relief from vaginitis.

Today, we know that *L. acidophilus* bacteria are the normal, protective inhabitants of vaginal membranes. But it took the 1920s research of Dr. R. Schroder to realize how important the right acid/alkaline balance or "pH" is for vaginal health along with bacterially produced optimal amounts of a germ-killing liquid we've all heard of: hydrogen peroxide. Turns out bacterial organisms produce this too and help to maintain balance. His studies showed that low levels of hydrogen-producing bacteria in the vagina are associated with high levels of inflammation, itching, and discharge. Women not suffering with vaginitis had higher acidic levels in their vaginal secretions and large amounts of friendly *L. acidophilus* bacteria. These women had very few "bad" bacteria in the vaginal area.

Forty years later, a report in the *American Journal of Obstetrics and Gynecology* noted that when *L. acidophilus* supplements were introduced into the vagina, pathogenic bacteria such as staphylococcus, streptococcus, and diplococcus, were replaced by these beneficial bacteria. The pH of the vaginal area shifted from an alkaline level to a more acidic level. The symptoms of vaginitis were promptly relieved and did not reoccur as long as women continued to consume the probiotic supplements. More recent research published in the *Journal of Infectious Diseases* emphasizes that *L. acidophilus* organisms play an important role in producing anti-microbial substances to keep the vagina healthy.

Dr. S.J. Klebanoff of the University of Washington School of Medicine found that hydrogen peroxide producing *L. acidophilus* bacteria help defeat unwanted bad bacteria in the vagina. Also, women who have low levels of these friendly bacteria in their genital tracts appear more likely to contract sexually transmitted diseases. Researchers at Wayne State University School of Medicine found similar results and emphasized that lactobacilli play an important role in controlling yeast overgrowth.

Boosting friendly bacterial populations offers protection against vaginitis. Not only is its occurrence and recurrence reduced, women can avoid having to repeatedly rely on potentially dangerous medical drugs commonly used to treat this condition. In contrast to conventional therapy, simultaneous supplementation with probiotics can help to protect against reinfection.

We know that a decrease in women's lactobacillus populations is associated with increased risk for vaginitis. In a study of 12 women with non-specific chronic vaginitis, it was found that women were most likely to be symptom-free when their populations of lactobacilli were highest. As the lactobacilli populations decreased, pathogenic bacteria were commonly detected, indicating a disturbed vaginal ecology.

In another study, samples of vaginal fluid from 60 women indicated that as the population of lactobacilli went down, the population of pathogenic bacteria went up. These findings were reconfirmed in another observational study when vaginal fluid from 53 women with nonspecific vaginitis and without the condition was analyzed and the populations of pathogenic bacteria were found to be elevated.

Supplementation with probiotics to boost the body's overall populations of lactobacilli can help to reduce chronic vaginitis.

Indeed, such supplementation with probiotics may be preferable to a course of metronidazole (Flagyl), which may kill both trichomonas and gardnerella. Metronidazole is known by doctors and pharmacists alike as the ultimate "bowel sweeper," taking everything—including friendly bacteria—with it.

Flagyl, made by G.D. Searle, is one of the most widely prescribed antibiotics. It was the first effective drug against vaginal infections (trichomonas), for which it is still widely used. By the mid-1970s, it was prescribed more than two million times annually.

"Noteworthy" incidence of breast cancer in rats has been found following dosing with metronidazole. The drug is characterized as having "considerable carcinogenic potential."

A subsequent animal study also reported "significant" excesses of breast cancer. While two short-term and inadequate human studies found no excesses of breast cancer, the animal evidence raises a clear warning.

On the other hand, with probiotics we have a safe alternative or complement to antibiotic use. In one study of 94 patients with non-specific vaginitis, treatment with a supplement to increase the body's populations of beneficial lactobacillus resulted in a decrease of pathogens and increase in the population of beneficial lactobacilli. Vaginal purity and vaginal pH also returned to normal. A cure or at least marked improvement in symptoms was documented in 80 percent of patients. Boosting the body's own healing response by restoring its pop-

ulation of friendly bacteria protects against reinfection and has a decided advantage over antibiotic therapy alone.

In a second study, 444 women with *trichomoniasis vaginalis* were treated with a supplement to raise populations of friendly bacteria. One year later, 427 (96.2 percent) were followed up, and 92.5 percent of them were found to be cured of clinical symptoms, while the remaining 7.5 percent had a positive symptom.

In another clinical report, 20 patients reported that they cured their candida vulvovaginitis with preparations designed to enhance their populations of friendly bacteria.

Once yeast overgrowth has been controlled with a bioadaptable form of hydrogen peroxide produced by *L. acidophilus* bacteria, vaginal inflammation will subside over time. However, never douche with over the counter forms of hydrogen peroxide because these concentrations can damage human cells in the body.

### How to Use Probiotics for Vaginitis

Be sure to choose a quality probiotic supplement containing lactobacillus and bifidus cultures and take it daily. Continue as long as the condition persists. Be sure to follow the recommended label instructions and work with your physician to determine the optimal dosage. It is important to maintain optimal levels of beneficial bacteria in the vaginal canal to maintain health and comfort.

To help rid yourself of vaginitis; it is also wise to support vaginal health through the digestive tract. Since yeast feeds on dietary sugar, slow down the spread of yeast and various fungal infections in the vagina by eliminating all refined and concentrated forms of sugar from the diet. Even fresh and dried fruit sugars should be avoided until the problem clears up. Nuts, seeds, cheese and some Indian and Chinese teas can also carry hidden mold and yeast spores. Avoid eating smoked meat, fish or smoked poultry and try not to buy meat products from animals raised on antibiotics. Check food labels for hidden sugars in salad dressings, canned soups and chips in cellophane bags.

### Candidiasis

If you're feeling "sick all over" and if you've been regularly using antibiotics, you could be suffering from complications of yeast syndrome. Fortunately, with use of holistic healing pathways, including use of probiotics, you can perhaps eliminate the condition.

An overgrowth in the gastrointestinal tract of the usually benign yeast (or fungus) *Candida albicans* is now becoming recognized as a complex medical syndrome called *chronic candidiasis* or the yeast syndrome. Many women have yeast syndrome but don't even know it is the reason they feel "sick all over." Yet, even women who know they suffer from yeast syndrome often live with this debilitating condition for years, because their doctors are unable to provide them with an effective and safe healing program.

The typical patient with the yeast syndrome is young and female. Indeed, women are eight times more likely to experience the yeast syndrome than men. They have usually been on estrogen drugs such as birth-control pills and have been given a higher than normal number of prescriptions for antibiotics, most notably tetracycline and metronidazole, and topical creams such as erythromycin.

Indeed, prolonged antibiotic use is believed to be the most important factor in the development of chronic candidiasis. Antibiotics suppress the immune sys-

---

*Indeed, prolonged antibiotic use is believed to be the most important factor in the development of chronic candidiasis*

---

tem and the friendly intestinal bacteria that prevent yeast overgrowth, strongly promoting the proliferation of candida.

That means that the gastrointestinal tract of candida sufferers often must be recultivated with friendly bacteria. Products that stimulate *L. acidophilus* or *B. bifidum* can help immensely as part of a comprehensive program that addresses the whole person. Probiotics are a natural supplement to aid in restoring such populations that can then enhance the healing response so that candida sufferers may get past the chronic infectious state.

### How to Use Probiotics for Candidiasis

Be sure to follow the recommended label instructions of a good probiotic supplement containing lactobacilli and bifidus and work with your knowledgeable health care provider to determine the optimal dosage.

# Chapter Thirteen

---❧---

## LOWER URINARY TRACT INFECTIONS (UTIS)

P robiotics are important to use as a follow up to antibiotics when being treated for urinary tract infections—as the antibiotics that eradicate infectious agents cause imbalances in the bacterial populations that protect against UTIs. This leads to risk of re-infection. Probiotics help to repopulate the body's beneficial bacteria that protect against UTIs.

By supporting the body's population of friendly bacteria, probiotics help to restore a normal flora following administration of broad-spectrum antibiotics.

"Emerging from the stigma of once being referred to as 'snake oil,' excellent scientific and clinical evidence now exists to indicate that probiotics do indeed have a role to play in medicine," note researchers from the University of Toronto, Lawson Health Research Institute, London, Ontario, Canada. "In urology, the most studied strains are *Lactobacillus rhamnosus* GR-1 and *L. fermentum* B-54 and RC-14. Their use daily in oral form, or once to three times weekly as a vaginal suppository, have been shown to reduce the urogenital pathogen load and the risk of urinary tract and vaginal infections. Organisms such as *Oxalobacter formigenes*, still in the R&D phase, offer great potential to reduce kidney stone formation via oxalate degradation in the intestine. Some studies using certain strains of *L. casei* suggest a possible effect against bladder cancer, while studies using *L. plantarum* 299 show significantly reduced infection rates in patients undergoing major surgical procedures. In short, specific probiotic strains hold much promise for use in the urology setting."

At the Yakult Central Institute for Microbiological Research, Kunitachi, Tokyo, the antimicrobial activity of the probiotic *Lactobacillus casei* against

*Escherichia coli* in rodent urinary tract infections was examined. A single administration of *L. casei* dramatically inhibited *E. coli* growth and inflammatory responses in the urinary tract. Multiple daily treatments with *L.casei* during the postinfection period also showed antimicrobial activity in this model. Other lactobacillus strains tested—*L. fermentum*, *L. jensenii*, *L. plantarum*, and *L. reuteri*—had no significant antimicrobial activity. "Taken together, these results suggest that the probiotic *L. casei* strain Shirota is a potent therapeutic agent for UTI."

### How to Use Probiotics for Urinary Tract Infections

Be sure to choose a quality probiotic supplement containing the probiotic cultures detailed in this chapter. Follow recommended label instructions and work with your physician to determine the optimal dosage.

# Chapter
# Fourteen

———⟲———

## COMPLICATIONS OF ANTIBIOTIC THERAPY

We have to remember that taking a course of antibiotics can be very difficult on some people, particularly children, the chemically sensitive, and elderly—and anyone with a sensitive stomach. What's more, many people must take antibiotics for protracted periods of time. Results are upset stomach, diarrhea, nausea, constipation and reduced immune function. Believe me, when patients have to take antibiotics for a month or longer, or when they are constantly being prescribed to them, it's no fun—and these are just a few of the complaints caused by antibiotics. The most common complications that result from antibiotic use are nausea, diarrhea, constipation and recurrent infections, including candidiasis or yeast infection, as well as itching in the vaginal and anal areas. In all of these, concurrent use of probiotics with antibiotics, that is, taking both simultaneously with three to four hours interval, and continuing to take probiotics following use of antibiotics, can play a remarkably beneficial role in reducing side effects and complications.

Almost all diarrhea caused by antibiotics is a result of the disturbance of the balance of friendly bacteria in the GI system. This is shown clearly in a study from the Department of Biological Sciences, Mississippi State University, Mississippi. There, researchers evaluated the efficacy of an oral electrolyte solution with and without fructooligosaccharides (FOS, a type of carbohydrate that selectively "feeds" beneficial bacteria) for treatment of acute diarrhea induced by cholera toxins. Although total bacterial counts recovered within 24 hours regardless of treatment, densities of potentially toxic enterobacteriaceae were higher for those treated with the oral electrolyte solution without FOS. Those

receiving the oral electrolyte solution with FOS had more lactobacilli. The researchers say, "The results show that secretory diarrhea disturbs the normal densities and relative species abundance of the microbiota...and that adding FOS to [oral electrolyte solution formulas] accelerates the recovery of bacteria perceived as beneficial while potentially slowing the recovery of pathogenic forms."

This is because when friendly bacterial populations are low due to use of antibiotics, the use of probiotics can promote and selectively enhance proliferation of beneficial bacteria in the hostile gastrointestinal tract.

In other words, probiotics rejuvenate decimated and dying populations of friendly bacteria that may be reduced with antibiotic use. This is critical, because with healthy bacterial populations, intestinal upsets such as diarrhea can be vanquished. We even know that the rotavirus, perhaps the most well known cause of childhood diarrhea in the world, can be overcome with friendly bacterial populations. We think what happens in both children and adults is that once

---

*Think of probiotics as the sheriff and his deputies in an old Wild West town. They'll drive out the bad guys.*

---

healthy bacterial populations are again re-established they ignite the immune system to recognize this villain and thereby destroy its presence.

By stimulating healthy populations of beneficial bacteria in your gastrointestinal tract, populations of pathogenic bacteria including *Escherchia coli*, *Clostridium perfringens* and others are displaced. Think of probiotics as the sheriff and his deputies in an old Wild West town. They'll drive out the bad guys.

Oral antibiotic therapy can alter gastrointestinal microflora. Some researchers note that lactobacillus therapy reduces the volume and duration of neomycin-associated diarrhea; however, they also observed a lot-to-lot change in clinical, results which they suggested might be due to variations in viability between lots of the probiotic preparations. For this reason selection of an effective probiotic is very important to get the best result. This means that all probiotics are not the same. Even the same probiotic supplements in different lots are not the same if they do not contain the same probiotic bacteria at the same potency.

Others report that concomitant therapy of *L. acidophilus* with amoxicillin/clavulanate was reported to decrease patient complaints of gastrointestinal side effects and yeast superinfection.

In experimental animals and in humans, administration of certain antibiotics caused disturbances in normal intestinal microflora, manifested by a sharp decrease in levels of lactobacilli and bifidobacteria, as well as the appearance of large amounts of enterobacteria and enterococci. Oral supplementation with bifidobacteria and lactobacilli, following cessation of antibiotics, resulted in restoration of intestinal microflora.

## Antibiotic-related Childhood Diarrhea

Live probiotic cultures are especially important to use concurrently with antibiotics for treatment of infantile acute diarrhea (caused by rotavirus or other agents), colitis, and hospital and antibiotic-associated diarrheas.

Indeed, most recently, pediatric researchers from Johns Hopkins University in Baltimore found that enhancing infants' gastrointestinal flora was shown to decrease incidences of diarrhea and diaper rash. In the study, presented at a children's nutrition conference in 1998, the researchers gave 140 children, ages four to eighteen months, baby formula supplemented with high doses of beneficial bacteria, lactobacilli and bifidobacteria. The result was a 20 percent reduction in diaper rash, fewer loose stools and less constipation among the probiotic supplemented babies.

In another study from *Clinical Pediatrics*, the effects of yogurt and Neomycin-kaopectate as treatment of infantile diarrhea were compared among 45 infants aged one to twenty-seven months. Infants treated with yogurt recovered more rapidly.

In the March 2004 issue of *International Microbiology*, we learn that colonic infection with *Clostridium difficile*, leading to pseudomembranous colitis, is a common complication of antibiotic therapy, especially in elderly patients. It has been suggested that a probiotic bacteria might prevent the development and recurrence of *C. difficile* infection. This double-blind, placebo-controlled study examines the role of probiotic administration in the prevention of *C. difficile*-associated diarrhea (CDAD) in elderly patients receiving antibiotic therapy. Consecutive patients (150) receiving antibiotic therapy were randomized to receive either a probiotic containing both lactobacilli and bifidus or placebo for

20 days. Upon admission to the hospital, bowel habit was recorded and a fecal sample taken. Trial probiotic or placebo was taken within 72 hours of prescription of antibiotics, and a second stool sample was taken in the event of development of diarrhea during hospitalization or after discharge. Of the randomized patients, 138 completed the study, 69 with probiotics in conjunction with antibiotics, and 69 with antibiotics alone. On the basis of development of diarrhea, the incidence of samples positive for *C. difficile*-associated toxins was 2.9% in the probiotic group compared with 7.25% in the placebo-control group. When samples from all patients were tested (rather than just those developing diarrhea) 46% of probiotic supplemented patients were toxin-positive compared with 78% of the placebo group.

# Antibiotic Uses, Complications, Nutrient-related Interaction:

| Drug | Common Uses | Potential Adverse Health Effects |
|---|---|---|
| All Antibiotics | | The use of antibiotics is lim ed because bacteria ma evolve resistance to them.Tl problem of resistance h been increased by the ina propriate use of antibiotics f the treatment of common vir infections. Such use remove antibiotic-sensitive bacter and allows the developme of antibiotic-resistant bacter Tuberculosis, for exampl once nearly eradicated in tl developed countries, increasing partly because resistance to antibiotics. |
| Penicillins | Are used to treat such diseases as syphilis, gonorrhea, meningitis, and anthrax. | Side effects of the penicillin while rare, can include allerg reactions such as skin rashe fever, and anaphylactic shock |
| Cephalosporins | May be used to treat strains of meningitis and in orthopedic, abdominal, and pelvic surgery. | Rare reactions to tl cephalosporins include skin ra and anaphylactic shock. |
| Aminoglycosides (e.g., streptomycin) | Inhibit bacterial protein synthesis and are sometimes used in combination with penicillin. | These tend to be more tox than other antibiotics. Ra adverse effects associate with prolonged use of amin glycosides include hearir loss and kidney damage. |
| Macrolides (e.g., erythromycin) | The macrolides work by interrupting protein synthesis. Erythromycin, one of the macrolides, is often used as a substitute for penicillin against streptococcal and pneumococcal infections. Other uses for macrolides include treating diphtheria and bacteremia. | Side effects may include na sea, vomiting, and diarrhea. |

| Drug | Common Uses | Potential Adverse Health Effects |
|---|---|---|
| lfonamides | The sulfonamides are effective against many types of bacteria, although some bacteria have developed resistance to them. Sulfonamides are now used only in very specific situations, such as urinary system infection and in lyme disease. | Side effects may include disruption of the gastrointestinal tract and hypersensitivity. |

| | Nutrients Depleted | More Adverse Reactions |
|---|---|---|
| nicillins, cephalosporins, uoroquinolones, acrolides, aminoglycosides, lfonamides | *Lactobacillus acidophilus, Bifidobacteria bifidum* (bifidus); vitamins $B_1$, $B_2$, $B_3$, $B_6$, $B_{12}$, K; biotin, inositol<br>Calcium<br>Magnesium<br>Iron. | Increased susceptibility to pathogens; constipation; diarrhea<br><br>Irregular heartbeat and blood pressure; osteoporosis; tooth decay<br><br>Asthma, cardiovascular problems, cramps, osteoporosis, premenstrual syndrome<br>Anemia, brittle nails, fatigue, hair loss, weakness |
| tracyclines, sulfonamides | *Lactobacillus acidophilus, Bifidobacteria bifidum* (bifidus); vitamins $B_1$, $B_2$, $B_3$, $B_6$, $B_{12}$, K; biotin, inositol | Increased susceptibility to pathogens; constipation; diarrhea |
| comycin | Beta-carotene; vitamins A & $B_{12}$ | Fatigue |
| -trimoxazole | *Lactobacillus acidophilus, Bifidobacteria bifidum* (bifidus), folic acid | Increased susceptibility to pathogens; constipation; diarrhea |

### How to Use Probiotics with Antibiotics

It is critical that consumers begin their use of probiotics during antibiotic therapy and continue such for at least two to three weeks post-therapy. If you are taking antibiotics, take probiotics at higher doses and 3 to 4 hours after antibiotic intake. Be sure to choose a quality probiotic supplement containing lactobacillus and bifidus cultures and take it daily even after antibiotic therapy is discontinued. Be sure to follow the recommended label instructions and work with your physician to determine the optimal dosage. (See also Appendix C.)

# Chapter
# Fifteen

———— ℮ ————

## HIGH CHOLESTEROL AND BLOOD LIPIDS

**H**eart disease is the number one cause of death in America and, by now, almost all of us recognize that high levels of cholesterol and triglycerides increase heart disease risk. Unfortunately, with all we know, there are still millions of Americans who suffer from high blood levels of each.

While medical drugs may help to reduce cholesterol levels, their side effects may make them less desirable than a safe natural remedy. Or it may be you want to hedge your bets, so to speak, using both drugs and natural therapies. Probiotics and probiotic-rich foods would make a good part of your supplement program.

The American Heart Association says that changes in life habits—cutting down on calories, reducing saturated fat and cholesterol in the diet, reduced alcohol intake and a regular exercise program—can help in the treatment of hypertriglyceridemia, the technical name for elevated triglycerides, an independent heart disease risk factor. Triglycerides are the form in which fat is found in the bloodstream. Here's some good probiotic news. Several studies have indicated that consumption of certain cultured dairy products resulted in reduction of serum cholesterol, as well as triglycerides.

One team found that serum cholesterol levels in men from a tribe of African Maasai warriors decreased after consumption of large amounts of milk fermented with a wild lactobacillus strain. Other researchers have found that serum cholesterol levels in bottle-fed babies decreased as the numbers of *Lactobacillus acidophilus* in their stools increased. Consumption of yogurt has also been shown to decrease serum cholesterol levels in humans and rabbits.

We also have reviewed reports showing a significant decrease in plasma cholesterol in rats fed milk fermented by *Streptococcus thermophilus*. Yet more studies find a significant decrease in serum cholesterol in rats fed milk fermented with *L. acidophilus*. And germ-free swine, after being exposed to *L. acidophilus* and developing normal flora, also experienced decreased serum cholesterol levels. Even laying hens find reduced cholesterol levels when fed *L. acidophilus*.

At the Metabolic Research Group, VA Medical Center, University of Kentucky, Lexington, two controlled clinical studies were performed to examine effects of consumption of one daily serving of fermented milk on serum lipids. In the first study, fermented milk containing *L. acidophilus* was accompanied by a 2.4 percent reduction of serum cholesterol concentration. In the second study, a different *L. acidophilus* strain reduced serum cholesterol concentration by 3.2 percent. Since every one percent reduction in serum cholesterol concentration is associated with an estimated two to three percent reduction in risk for coronary heart disease, regular intake of fermented milk containing an appropriate strain of *L. acidophilus* has the potential of reducing risk for coronary heart disease by six to ten percent.

"Recent medical studies at the Shinshu University in Japan find that *Lactobacillus acidophilus* bacteria can suppress the reabsorption in the liver of bile acids carrying cholesterol and improve the removal of cholesterol from blood through stool excretion," notes Aristo Vojdani, Ph.D., M.T. "In another study in Argentina, lactobacilli bacteria were found to lower total blood cholesterol by 22 percent and triglycerides by 33 percent. A research report from Denmark published in the *European Journal of Clinical Nutrition* notes that lactobacilli bacteria significantly lowered blood pressure in men and women 18 to 55 years of age after eight weeks of supplementation. Those in the control group not receiving lactobacillus bacteria had no reduction in their high blood pressure. Such scientific evidence provides valuable insight toward reducing the risk of unhealthy cholesterol levels associated with heart disease."

Frederic Vagnini, M.D., medical director of the Cardiovascular Wellness and Longevity Centers of New York, says probiotic supplementation is a wise strategy for optimal cardiovascular health. Author of *The New York Times* best selling book, *The Carbohydrate Addict's Healthy Heart Program*, Dr. Vagnini says beneficial bacteria consumed on a regular basis help keep cholesterol levels within

healthy ranges. Food absorption and liver functions improve. Also, probiotic supplements offer a safer way to clean up excess cholesterol without the side effects of cholesterol-lowering drugs.

Thus, we see probiotics, in addition to their many other health benefits, can play an important complementary role in cholesterol-lowering regimens. They do so through the assimilation of cholesterol in the digestive tract. Such assimilation in the small intestine may be important in reducing the absorption of dietary cholesterol from the digestive system into the blood.

Be sure your probiotic formula is combined with FOS, which will amplify the benefits of probiotics by also reducing levels of triglycerides. In particular, FOS, often added to quality probiotic supplements, selectively modifies the colon's bacterial populations and liver's formation of lipids. Both of these, in turn, help the body to beneficially lower serum blood lipids. What's more, FOS is completely nontoxic and without any drug or nutrient interactions whatsoever. C.M. Williams of the Hugh Sinclair Unit of Human Nutrition, Department of Food Science and Technology, University of Reading, Reading, UK, notes that "convincing lipid-lowering effects of the fructooligosaccharide and inulin have been demonstrated in animals . . ."

FOS seems to work best if persons are consuming a diet high in carbohydrates. That is because we know that a key constituent of FOS, inulin, works by inhibiting the liver's synthesis of fatty acids and that this is the major pathway for its triglyceride-lowering effects.

Biochemical studies with isolated liver cells have demonstrated that by altering gene expression inulin reduces the activity of the liver's key enzymes which are related to formation of fatty acids or assembling triglycerides. This pathway is relatively inactive in humans unless one is consuming a high carbohydrate diet. But if you like pastries, baked goods, candy and soft drinks or other forms of starch and carbohydrates such as rice and potatoes—then a probiotic-FOS combination could be your best friend, as it can really help to lower blood lipids including cholesterol and triglycerides. The studies indicate that the triglyceride lowering effect takes about eight weeks to establish.

## How to Use Probiotics to Lower Cholesterol & Triglycerides

Probiotics and probiotic-rich foods aid in lowering cholesterol and triglycerides. Use quality probiotic supplements containing lactobacillus and bifidus cultures fortified with FOS and take daily. Be sure to follow the recommended label instructions and work with your physician. Do not discontinue other medications without your doctor's advice.

# Chapter
# Sixteen

─────── ❧ ───────

## CANCER PREVENTION

A recent report in *Nutrition Action Health Letter* notes that, "If you're not a smoker, the cancer that's most likely to kill you—other than breast or prostate—is cancer of the colon or rectum. In 1999, an estimated 94,700 Americans were diagnosed with colon cancer and 34,700 with rectal cancer. Within ten years, 55 percent of them will die."

But we have reason to be optimistic. We can prevent or markedly reduce our risk for colon cancers through our dietary habits. It is in the area of prevention of one of our most deadly cancers, that of the colon, that probiotics offer stellar benefits. We don't think of the friendly bacteria in our gastrointestinal tract as important components of cancer prevention. Yet, healthy populations of friendly bacteria play many important roles in our body's quest to defend itself against malignant disease.

"One of the most promising areas for the development of functional foods lies in modification of the activity of the gastrointestinal tract by use of probiotics, prebiotics and synbiotics," notes a 2002 report in the *British Journal of Nutrition.* "While a myriad of healthful effects have been attributed to the probiotic bacteria, perhaps the most controversial remains that of anticancer activity."

Yogurt, and lactic acid-producing bacteria have received much attention as potential cancer-preventing agents in the diet, note researchers at Northern Ireland Centre for Diet and Health, School of Biomedical Sciences, University of Ulster, Coleraine, Northern Ireland. "It is usually considered that the mechanism of the action is by increasing the numbers of [lactic acid-producing bacteria] in

the colon, which modifies the ability of the microflora to produce carcinogens. Prebiotics such as non-digestible oligosaccharides appear to have similar effects on the microflora by selectively stimulating the growth of lactic acid-producing bacteria in the colon." Evidence for cancer-preventing properties of pro- and prebiotics is derived from studies on fecal enzyme activity in animals and humans, inhibition of genotoxicity of known carcinogens *in vitro* and *in vivo*, suppression of carcinogen-induced preneoplastic lesions and tumours in laboratory animals.

In the February 1980 issue of the *Journal of the National Cancer Institute*, the effect of diet and *Lactobacillus acidophilus* supplements on fecal microflora enzyme activity was studied in humans. Compared to vegetarians, omnivores eating a Western-type diet had higher levels of beta-glucuronidase, nitroreductase, azoreductase, and steroid 7-alpha-dehydroxylase in their fecal microflora. Removal of red meat or addition of fiber in the form of bran or wheat germ to the diet of omnivores for 30 days had no effect on beta-glucuronidase, nitroreductase, or azoreductase activity. However, the addition of viable *Lactobacillus acidophilus* supplements to the diet of omnivores significantly decreased fecal bacterial beta-glucuronidase and nitroreductase activities. Thirty days after lactobacillus supplements were curtailed, fecal enzyme levels returned to normal base-line activities. "These findings suggested that the metabolic activity of the fecal microflora was influenced by diet and could be altered by lactobacillus supplements and to a lesser extent by dietary fiber."

Some of these studies indicate that combinations of pro and prebiotics (synbiotics) are more effective. Epidemiological studies provide some, although limited, evidence for protective effects of products containing probiotics in humans.

Take for example, beta glucuronidase, an enzyme that disrupts our ability to detoxify environmental chemicals and hormones, such as estrogen, that the body naturally produces. High levels of beta glucuronidase in the body appear to put people at risk for both breast and colon cancer.

However, a healthy flourishing population of friendly bacteria helps to displace unfriendly bacteria responsible for producing this enzyme. Your protection against two prevalent, often deadly cancers is thereby enhanced.

Very recent research from the American Health Foundation, Valhalla, New York, indicates that FOS has a significant chemopreventive potential and can

prevent formation of precancerous lesions (i.e., polyps) in the colon, markedly delaying the cancer process.

We don't know precisely how probiotics exert their anti-cancer benefits but believe that by enhancing populations of bifidobacteria, this may result in direct removal of procarcinogens, indirect removal of procarcinogens, or activation of the body's immune system. In one experimental study, it was shown that a particular strain of *L. acidophilus* could prevent tumor formation in rats challenged by a chemical carcinogen. The researchers involved in the study postulate that the inhibition of cancer "may involve (a) inhibiting the growth of putrefactive bacteria and in turn reducing the production N-nitroso compounds; (b) direct reduction of secondary nitrites and bile salts ... and (c) stimulation of intraperitoneal macrophages and their enzymes which may play a role in the antitumor effect ..."

Tumor suppression via the body's immune response system may also be affected by the presence of bifidobacteria. Cell wall fractions of *Bifidobacterium infantis* are known to contain active anti-tumor constituents. Meanwhile, healthy populations of beneficial bacteria activate the immune system's macrophages and they become more alert on the job.

Bolstering the body's balance of *Lactobacillus acidophilus* may truly prevent colon cancer. In an experimental crossover study, 21 healthy subjects were given either milk with viable lactobacillus cultures or milk without the cultures. The fecal concentration of bacterial enzymes that convert procarcinogens into full-fledged carcinogens was significantly reduced within one month in persons receiving the lactobacillus cultures but not in the group receiving the placebo.

In another study, the authors noted that the link between diet and colon cancer is explained, in part, by the alteration of fecal bacterial enzyme activity caused by the Western-style diet which is high in meat and saturated fat, and low in fiber.

In an *in vivo* study, using probiotic Lactobacilli "was associated with reduced prevalence of colon cancer and mucosal inflammatory activity," say researchers from the Department of Microbiology, University College Cork, Ireland.

## Breast Cancer

Breast cancer is the cause of over six-hundred-thousand deaths worldwide every year. And forty-six thousand in the United States. The majority of these were among postmenopausal women under seventy: premature death sentences, robbing them of fifteen to twenty years of life. According to a renowned international authority: "It is the leading cause of cancer death in women throughout the industrialized world and in many developing countries."

Fortunately, breast cancer is another malignant disease that friendly bacteria may protect against. For example, in one experimental study, "the growth of both tumor lines was significantly inhibited by supplementing the diet with nondigestible carbohydrates [i.e., FOS]. Such nontoxic dietary treatment appears to be easy and risk free for patients, applicable as an adjuvant factor in the classical protocols of human cancer therapy."

Lactobacillus inhibits beta-glucuronidase, the fecal bacterial enzyme that prevents the body from detoxifying more potent forms of estrogen (such as estradiol) into nontoxic forms (e.g., estriol). Toxic forms of estrogen increase women's risk of breast cancer, but the more benign forms reduce risk. Thus, probiotics may play an important role in normalizing the gut flora that would help to defuse toxic estrogen.

## Liver Cancer

Aflatoxins have been shown by studies to be acute toxicants and liver carcinogens. They are found in many food items, especially poor quality peanut butter. In a study that examined the ability of lactobacilli to bind to and kill foodborne carcinogens, this strain of probiotic showed potential in the detoxification of aflatoxin B1, aflatoxin B2, and aflatoxin G1. Binding activity was both time and concentration dependent.

## How to Use Probiotics to Lower Your Cancer Risk

Do not consider probiotic supplements as the cancer cure. Consult your physician for your cancer treatment. Take a probiotic supplement containing lactobacilli and bifidus with FOS to supplement your doctor recommended program.

# Chapter
# Seventeen

———— ◌ ————

## SMOKERS BENEFIT FROM LACTOBACILLUS

P robiotic supplements with lactobacilli appear to reduce many of the damaging effects on smokers' blood vessels, notes researcher Marek Naruszewicz in the *American Journal of Clinical Nutrition*.

Some 36 smokers with an average age of 42 were given either the lactobacillus supplement or a placebo. Six weeks later, persons receiving the probiotic had healthier blood vessels and their systolic blood pressure dropped from 134 to 121 mg Hg.

In addition, levels of plaque-causing low-density lipoprotein cholesterol went down and beneficial high-density lipoproteins increased; levels of fibrinogen (responsible for blood clots) dropped some 21 percent; and levels of the proinflammatory interleukin-6 and white blood cell adhesiveness, all indicators of impaired blood flow, declined by 41 and 40 percent, respectively. Levels of oxidation (caused by excess free radical activity) declined 31 percent.

***Key health tip***: Few consumers are aware that lactobacilli produce propionic acid, a precursor chemical for the anti-inflammatory drug ibuprofen. This might account for some of the probiotic's benefits. In addition, the authors suggest that our diets are deficient in these beneficial bacteria. They add that supplementing with probiotics is a "nonpharmacological alternative for the management of risk factors and the prevention of atherosclerosis."

# Chapter
# Eighteen

─────⌒─────

## TRAVELER'S DIARRHEA

Pack your probiotics when you travel. Because the high-risk countries of the developing world have not sufficiently addressed the problem of their unhygienic environment, those who travel to such countries run the risk of coming down with traveler's diarrhea. The usual incidence of travel related diarrhea is 15 to 56 percent, a wide variation, of course, due to different factors depending on which regions are visited.

Studies have demonstrated that probiotics can provide substantial protection against traveler's diarrhea, most often related to ingestion of pathogens to which our bodies are unaccustomed. In a study, two capsules of DDS® probiotics from UAS Laboratories before breakfast each day (starting one week before departure and throughout the trip) helped to markedly reduce incidence of diarrhea amongst travelers with only three of approximately eighty individuals coming down with traveler's-related diarrhea.

In a 1997 study, researchers noted that a study among New York travelers who briefly visited developing countries for one to three weeks revealed encouraging data that probiotics were effective in preventing traveler's diarrhea.

In a placebo-controlled study involving travelers, a most extensively studied lactobacillus strain decreased the incidence of traveler's diarrhea among 820 persons traveling to two separate destinations in Turkey. One group received lactobacillus while the other received a placebo, both to be consumed throughout the duration of the trip. The incidence of diarrhea in the placebo group was 46.5 percent and only 41 percent in the lactobacillus group, indicating an over-

all protection of 11.8 percent. The lactobacillus was well tolerated, and suggests that it can be administered in healthy people to diminish the risk of traveler's diarrhea.

## How to Use Probiotics for Traveler's Diarrhea

Be sure to choose a quality probiotic supplement containing lactobacillus and bifidus cultures fortified with FOS and take it with you when you travel. Be sure to follow the recommended label instructions and work with your physician to determine the optimal dosage. Do not discontinue medications unless advised to do so by your physician. Also, avoid consumption of non-bottled beverages and raw produce.

# Chapter
# Nineteen

---ᘓ---

## PROBIOTICS AND AUTISM

Autism is a developmental disease characterized by a spectrum of symptoms ranging from decreased verbal skills and social withdrawal, to repetitive behavior and violent outbursts. Genetic analysis has yielded a few potentially interesting genes; however no clear linkage has been established, note experts. For this reason, it has been suggested that the etiology of autism may involve multiple causes. This, in large part, explains why so many different theories abound.

One such theory is that autism is caused or exacerbated by heavy metal poisoning. Environmentally acquired heavy metals including mercury, either through some causal contact or through vaccination, have been postulated as a major culprit. (Mercury is used as a preservative in some types of vaccinations.) Mercury is thought to be exerting its neurological effect on the brain. There are of course other areas of causation that are also critically important. But autism as a form of mercury poisoning is one area that we need to take seriously.

The standard treatment parents of autistic children commonly use has been to apply medically prescribed chelating agents in an attempt to extricate the mercury.

But the human body has an amazing ability to detoxify itself when given the proper nutrients. "One missing component in the treatment is the utilization of the body's own detoxification mechanisms," notes autism/probiotic expert Mark Brudnak, Ph.D., N.D., author of the *The Probiotic Solution* (Dragondoor Publications, 2003) and developer of probiotics formulas. In several articles in the journal *Medical Hypotheses*, Dr. Brudnak combines several potential mech-

anisms associated with autism to construct a theory that explains how the condition could develop and progress, and how probiotics can help.

"Arguably," he says, "the largest detoxification component of the body—the endogenous enteric bacteria—are an enormous reservoir, which can be constantly and safely replenished."

### Piecing Together the Puzzle of Autism:
### Linking the Digestive Tract to the Brain

Next, we went to Great Smokies Diagnostic Laboratory, which has been pioneering many different diagnostic tests that allow us to determine whether the gut flora of autistic children are in balance, and whether the intestinal tract suffers from excess permeability. Could there be a link between an imbalance of gut flora, intestinal permeability, and autism? (By permeability, we mean that the gut is leaky and is allowing undigested chemicals to pass directly through into the bloodstream. Some of these compounds are thought to be toxic and manifest their toxicity as autism symptoms.)

Childhood vaccinations have been implicated in the onset of autism, while diet has been implicated in its subsequent prognosis, Dr. Brudnak points out. A strong gut-brain connection is also apparent, with poor digestive function often appearing as a hallmark of the disorder.

According to the *Great Smokies Connection* newsletter:

"Dr. Brudnak speculates on the following chain of events. In early childhood, sensitivity to a vaccine, or a reaction to a mycobacterial infection, could disrupt pivotal molecular mechanisms that regulate how specific genes in the body switch 'on' or 'off'—what's known as genetic expression. This may trigger malfunctioning of the immune and gastrointestinal systems, particularly in gut-associated lymphoid tissue, which Dr. Brudnak cites as 'a major contributor to the pathological manifestations of autism.'

"When this happens, proteins are no longer properly broken down in the digestive tract. Cells in gut tissue die off prematurely, as the gut lining becomes 'leaky' and unable to repair itself. Compounds in the diet, like casein and gluten, normally kept at bay, may then permeate into the blood stream. Their activated by-products, called exorphins, could act directly on the brain to trigger opioid-like effects associated with autistic symptoms.

"'Such a scenario could explain why restoring healthy gut barrier func-

tion in autistic children is a treatment approach that 'has met with a degree of success,' Dr. Brudnak observes. Enzyme therapy (which improves the gut's ability to break down proteins) and probiotics (supplementation with beneficial gut microbes that help repair the intestinal lining) have both produced positive clinical results in autistic children, he points out.

"In most cases symptoms of autism begin in early infancy. However, a subset of children appears to develop normally until a clear deterioration is observed. Many parents of children with 'regressive'-onset autism have noted their children were given antibiotics immediately prior to the regression and that such use was followed by chronic diarrhea. This leads researchers to speculate that, in a subgroup of children, 'disruption of indigenous gut flora might promote colonization by one or more neurotoxin-producing bacteria, contributing, at least in part, to their autistic symptomatology.' "

This line of thought stimulated recent research at the Section of Pediatric Gastroenterology and Nutrition, Rush Children's Hospital, Rush Medical College, Chicago. To test this hypothesis, researchers took 11 children with regressive-onset autism for an intervention trial using a minimally absorbed oral antibiotic. Short-term improvement was noted using multiple pre- and post-therapy evaluations. "These results indicate that a possible gut flora-brain connection warrants further investigation" as a "meaningful prevention or treatment in a subset of children with autism."

Now let's take this even further and look at what happens to the gastrointestinal health of children with chronic gastroneurological-related disorders.

**Chronic Immune Reactivity May Damage Intestine**

"The challenge that many chronic disorders pose to modern medicine is that they often emerge as an interrelated tapestry of imbalances within the human body, rather than in response to a single, isolated cause," notes the newsletter. "And autism may be a prime example of this."

Many children with autism have chronic digestive problems. In fact, gastrointestinal symptoms in autistic children often first appear in conjunction with initial changes in emotion and behavior during the onset of autism, leading researchers to suspect a gut-brain connection.

A recent study reported in the *American Journal of Gastroenterology*

lends strong support to this possible gut-brain link. Researchers performed a colonoscopy on 60 children with autistic spectrum disorders who also had symptoms such as stomach pain, constipation, bloating, and diarrhea. The autistic children had much greater evidence of intestinal lesions than healthy children or non-autistic children with similar digestive problems.

Over 90 percent of autistic children showed clinical evidence of chronic enterocolitis, such as lymphoid nodular hyperplasia, a sixfold greater rate than found in the non-autistic children with inflammatory bowel disease.

"The pathology seems to reflect a subtle new variant of inflammatory bowel disease…" the researchers concluded, a type of "autistic enterocolitis."

Enterocolitis is an inflammation of the mucous membrane of the intestine. Researchers are not sure what could be causing the condition in children with autism, although it usually arises from chronic immune reactivity.

In autism, such immune responses might be triggered by substances in the diet (eg., opioid peptides), viral agents (such as measles virus), mercury, or other causes, the researchers speculated.

The opioid peptide theory was first presented to the medical world in 1979. Excess peptides (breakdown products of dietary proteins) act as opioids affecting neurotransmitters within the central nervous system.

In the normal course of events, proteins are digested in stages by enzymes; first to peptides (the intermediate compounds), then to smaller amino acid components, which are absorbed into blood capillaries in the gut mucosa. The larger peptides are generally unable to cross this membrane barrier, but when they do, they can act as opioids affecting neurotransmitters in the brain causing abnormal behaviors and/or activity. This theory suggests a higher percentage of these opioid peptides reach the brain in autistic children.

These incompletely digested peptides—known as exorphins, casomorphins, and gluteomorphins—usually come from milk proteins such as casein or from wheat (gluten) and are structurally similar to morphine. In experimental studies, they have been shown to exert a morphine-like neurological influence. The formation of excess peptides in the gut is possibly associated with sub-optimal enzyme activity or an insufficient supply of enzymes required to breakdown these peptides. This may be genetic in origin, or caused by other factors, such as enzyme inactivity secondary to nutritional deficiency, or by altered gut microflora. So if we repair the imbalance of beneficial bacterial organisms in the gut and

the gut lining, we have a chance to help some of our children with autism.

Indeed, a report from a dietician at the Royal Free Hospital, London, and published in the *Journal of Family Health Care* recently discussed the link between autism and abnormal gut flora "and the use of probiotics and prebiotics in improving the integrity of the gut mucosa."

"The gut-brain connection is now recognized as a basic tenet of physiology and medicine," writes Eammonn M. M. Quigley, MD, in a related editorial, "and examples of gastrointestinal involvement in a variety of neurological diseases are extensive."

Andrew Wakefield and colleagues have raised the possibility that a subset of children with pervasive developmental disorder (which includes autism), particularly those with a history of developmental regression and chronic gastrointestinal symptoms, have a disregulated immune response to the measles antigen from the measles-mumps-rubella (MMR) vaccine. This has been suggested as a possible precipitating factor associated with intestinal abnormalities.

### Did You Know—What is PDD?

Pervasive developmental disorder (PDD) is an umbrella term used to describe a group of disorders, including autistic disorder, which involve delayed development of communication and social-interaction skills and particular behavioral abnormalities. Although both genetic factors and environmental insults have been implicated in the pathogenesis of PDD, the underlying causes remain poorly understood.

### Probiotics' Role

Besides aiding repair of the gut lining and improving digestion, there is both anecdotal and clinical evidence that probiotics can help with detoxification, notes a recent report from *Clinical Pearls*, one of the nation's premiere nutrition newsletters. "Aerobic organisms have been shown to readily detoxify mercury. . . . According to the American Academy of Pediatrics, 90% of methylmercury is excreted through bile in the feces. . . . With large numbers of probiotic bacteria, mercury can effectively be driven toward expulsion. The administration of probiotics would prevent any recycling of toxic mercury. Mercury can cause an autoimmune response."

Obviously, we don't know all the answers yet, but use of probiotics appears

to be a promising lead in helping children with this very difficult-to-treat condition. If your child's autism is accompanied by gastrointestinal distress, the potential for probiotics to help might be further amplified.

This pivotal role of gut function in physical and emotional health is a central tenet of functional medicine and integrative treatment. Great Smokies Laboratories and others provide a variety of gastrointestinal assessments to help practitioners to detect and treat gut dysfunctions that may underlie or contribute to symptomatology in a diverse range of illnesses, including PDD and autism.

# Chapter Twenty

———— ᘒ ————

## THE SMART PROBIOTIC SHOPPER

There are many products sold today as probiotic supplements claiming to provide live friendly bacteria and offer many nutritional and therapeutic benefits. Most of the time, consumers have been cheated as many of these so-called probiotic supplements do not have any live probiotic bacteria and do not meet their claims.

First, to insure that friendly bacteria in dietary supplements actually provide their therapeutic benefits, they must implant and propagate rapidly once in the gut to avoid being eliminated entirely. Thus, the bacteria must be able to survive the high stomach acidity and then actually adhere to intestinal epithelial cells even in the presence of high levels of bile salts.

It should be recognized that being live organisms, bacteria in such preparations do not readily tolerate the harsh acidic environment in the stomach, and may be totally compromised by the time they reach the intestine. Even those bacteria that do survive the strong stomach acid may be utterly compromised and may not to be able to compete in the intestine for food and energy. Thus, they cannot colonize the intestine.

A second serious problem is that the majority of products we and our research associates have tested do not provide live cultures—even though they claim to do so on their labels. That is, they lack stability. By the time, these bacteria have been subjected to the rigors of handling, transportation, changes in temperature and shelf storage most of them have died.

In one study, 70 to 80 percent of samples did not measure up to label claims. In fact, 50 percent did not even have 10 percent of the claimed number of live

microorganisms. Some products did not even have the bacteria that they claimed to have. One product had *Streptococcus lactis* and several samples had pathogenic organisms present. These reflect not only the observations of our own research, but of previously published papers from leading experts in the field of microbiology.

Most recently, ConsumerLab.com, as part of its mission to independently evaluate products that affect health, wellness, and nutrition, purchased many leading probiotic products sold in the U.S. and tested them to determine whether 1) they possessed the claimed amount of viable bacteria or, if not listed on the label, at least 1 billion live organisms per maximum suggested daily serving, 2) they were free of contamination with yeast, mold, and types of bacteria with disease-causing potential, and 3) tablets disintegrated properly so that their contents would be released, or if enteric-coated, their contents would be released after passing through the stomach.

## What CL Found

ConsumerLab.com purchased 25 probiotic products: 19 were for use by the general population, 3 were specifically marketed for use by children, and 3 were yogurts. Among these, eight products claimed from 1 billion to 6 billion live organisms per daily serving. Thirteen other products claimed specific numbers of live organisms (some as high as 60 billion) but only *as of the time of manufacture*—not indicating the number that would be in the product at the time of use. The yogurts and one supplement did not specify bacterial counts.

On testing, ConsumerLab.com found that eight of the products contained less than one percent of the claimed number of live bacteria or of the expected minimum of 1 billion. In fact, six products had only a few thousand live bacteria—*one-ten thousandth of the amount claimed or expected*. Interestingly, products that did not claim a specific number of live bacteria at the time of use were much more likely to have been low, while seven of the eight products that gave expected numbers at the time of use (not limited to the time of manufacture) met these counts. It is quite likely that products that were low in viable bacteria may not work.

None of the products were contaminated with pathogenic bacteria, mold, or fungus. All tablet products disintegrated properly so that their bacteria would be released in the body. The one enteric-coated capsule passed

special testing that confirmed its ability to pass through the stomach and deliver its bacteria to the intestine.

To learn about other products, visit www.consumerlab.com on the web. You can sign up for their supplement testing results. These will prove extraordinarily educative and help to make you a better shopper.

# Chapter
# Twenty-One

──────⟋ℰ⟍──────

## SELECTION CRITERIA FOR PROBIOTIC
## SUPPLEMENTS

A ll probiotic products are not alike and do not have similar nutrition-
al and therapeutic values. The name probiotic does not mean any-
thing unless it contains the right strain(s), in the right amount (potency), in
the right condition (viable), in the right formulation and is GRAS (generally
recognized as safe).

For this reason one needs to know the strain, its viability, implantation cri-
teria, and other features and health benefits.

### Strain Selection

Lactic acid bacteria have a long history of safe use in dairy products.
However, some probiotic supplements now contain bacteria, which have no
record of safe use in humans or even animals. There are instances of probiotic
supplements containing soil bacteria that are not normal inhabitants of the
human gastrointestinal tract. These cultures may potentially be pathogenic. It is
imperative to select bacteria for incorporation in probiotic supplements that are
on the GRAS list. For example, *Lactobacillus acidophilus* species and some bifi-
dobacterium species are considered GRAS. Safe, proven cultures are your first
and most important criteria for selection.

Any new bacterial culture that has no history of prior safe use in humans
should be subject to toxicological studies prior to incorporation in any probi-
otic supplements. We want to know that the culture is benefiting, not harming
the host.

The bacterial strains used in a superior probiotic supplement should play an important role in:

- Colonization within the intestinal, respiratory and urogenital tracts
- Cholesterol metabolism
- Inhibiting the carcinogenesis, directly or indirectly, by stimulation of the immune system
- The metabolism of lactose, the absorption of calcium and the synthesis of vitamins
- Reduction of yeast and vaginal infection
- Constipation and diarrheal diseases
- Gastritis and ulcers
- Acne and skin problems

Additionally, the culture should adhere to the intestinal walls and proliferate. The probiotic strain must be proven to survive stomach acids in human subjects. And of course, it should produce natural antibiotics, lactic acid and hydrogen peroxide and inhibit pathogenic bacteria such as:

- *Bacillus stearothermophilus*
- *Escherichia coli*
- *Streptococcus faecalis*
- *Salmonella typhosa*
- *Salmonella schottmuelleri*
- *Streptococcus faecalis var liquifaciens*
- *Shigella dysenteriae*
- *Streptococcus lactis*
- *Shigella paradysenteriae*
- *Psuedomonas fluorescens*
- *Psuedomonas aeruginosa*
- *Staphylococcus aureus*
- *Vibrio comma*
- *Klebsiella pneumoniae*
- *Sarcina lutea*
- *Serratia marcescens*
- *Proteus vulgaris*

*Source: US Patent #3,689,640 In Vitro Antibacterial Activity of DDS-1 Lactobacillus Acidophilus.*

Not all strains of *Lactobacillus acidophilus* and other probiotics are acid-resistant. Selecting acid-resistant strains of *L. acidophilus* and other probiotics is the key to the success of the probiotic supplement. It is important to remember that enteric coating of bacteria is a poor and unproven substitute for actual acid resistance. Stay away from enteric-coated cultures for a few reasons. In nature these bacteria are not enteric coated. The process of coating these live bacteria with a protective layer may in fact kill them and reduce their viability. If these cultures are supposed to get into the intestinal tract on their own and be acid resistant, the whole process of enteric coating is not necessary.

## Probiotic Supplements with Multiple Bacteria

Some probiotic supplements now contain several different cultures; many of these bacterial cultures have no safe-use history in human health and nutrition. These bacteria may be antagonistic to each other and may alter the gut flora in an undesirable way. So it should not be believed that if one bacterium is good, multiple bacteria combined together are even better. To the contrary, a few select cultures have been proven beneficial and almost all the others are yet to be proven.

*L. acidophilus* and bifidobacterium species are normal inhabitants of the human gastrointestinal tract and are GRAS. Probiotic formulations containing these beneficial bacteria along with prebiotic fructooligosaccharides (FOS) are considered safe and offer many of the health benefits described earlier.

## Manufacturing

The manufacturing process used to produce microorganisms for use in probiotic supplements plays an important role in the viability of the culture. The medium, the temperature and other associated factors influence the viability and identity of the microorganisms. If the probiotic supplements do not contain the same microorganisms with the same viability, they will not offer the same, consistent, good results. Also make sure that the probiotic culture has not itself been contaminated with other harmful bacteria during manufacturing process and packaging. Make sure the company manufacturing the product has a strong history of providing proven safe cultures (do not let yourself be a guinea pig).

## Viability

The viability of probiotics is not only strain-dependent but is also influenced strongly by their physiological and chemical environment. For example probiotics in liquids including milk and yogurt do not normally survive longer than a few weeks.

Exposure of probiotics to oxygen decreases the stability of probiotic bacteria. For this reason, eliminating oxygen from and including nitrogen into probiotic supplement bottles can enhance the stability of probiotics.

## Guarantee/Assay

In order to know more about the keeping qualities of a probiotic product, it is important to know that the supplement is tested for viable microorganisms at the time of manufacturing and at the expiration date. This quality control procedure is important to the manufacturer as well as the consumer.

The viable cells are guaranteed as CFU (colony forming units) per gram at the time of probiotic supplement packaging. If the supplement does not list viable cells, or does not list the amount in CFU form, it is not valid. Consumption of probiotic supplements with two to five billion CFU per day is necessary to have any chance of offering significant beneficial effects.

## Storage, Handling and Shipping

Refrigerated storage of probiotic supplements (40°F) is recommended to maintain the viability of the microorganisms. This means even before the bottle is opened! Just like with yogurt, cheese and other refrigerated cultures, probiotic supplements, if not kept refrigerated, may spoil and lose potency rapidly.

However, some probiotic supplements, with the use of new stability improvement technology, have been shelf-stable for two years.

Probiotic supplements should be shipped in insulated containers via airfreight to avoid exposure to heat. Viability will not decline with short exposure to heat during shipping. Some companies package probiotic supplements in nitrogen-flushed bottles to maintain viability of the microorganisms during shipping and handling. It is certainly a good idea for these supplements to contain higher potency (higher CFU) than guaranteed on the label. This ensures that at a minimum, you get more than you pay for.

## Glass Bottle vs. Plastic Bottle

Probiotics are "anaerobic" organisms, meaning they live in the absence of oxygen. Therefore, exposure to air is undesirable. This makes glass a preferred container over plastic, which is somewhat porous. Probiotics packaged in plastic bottles can lose potency during prolonged storage.

## Dairy vs. Non-Dairy

Some Candida specialists recommend that individuals who are allergic to dairy products should consume non-dairy probiotic supplements for better results. This of course makes sense. If an individual has dairy sensitivities, suffers from yeast infections and so forth, it is a good idea to minimize exposure to dairy and dairy-based products.

## Prebiotic/Probiotic Combination

Combinations of prebiotics with probiotics offer better opportunities for the probiotic bacteria to grow. They can then multiply faster in the gastrointestinal tract as prebiotics selectively feed probiotics. Since yeast and pathogenic cultures are absent, and the probiotic product has its own supply of prebiotics, this is an excellent choice for yeast sufferers.

## Capsule, Tablet, Powder or Liquid?

Capsules are a preferred form of supplementation over powder. Some individuals find it difficult to measure exact dosages with the powder. In addition, each time the powder bottle is opened, the contents are exposed to atmospheric contamination. The powder is oxidized, and is exposed to humidity as well as to some potential contaminants. The spoon used to measure the powder may also add to the contamination if it is not sterile, as well as adding moisture to the powder. For these reasons, deterioration of powder tends to be more rapid when compared to capsules and tablets. However, there is versatility with powder when using with mixes for children or even for esoteric Candida treatments (beyond the normal oral routes).

- Capsules add another layer of insulation against the potential for contamination, moisture and oxygen related damage, etc. Consumers and health professionals alike prefer capsules due to convenience and viability.

- Chewable tablets are a good choice for children and elderly people who have difficulty swallowing and even those seeking to benefit the upper digestive tract. This may be for halitosis, (bad breath) for the esophagus (GIRD) or similar problems. Chewable acidophilus (bifidus does not lend itself to viable tablet manufacturing) is vegetarian (vegan). Those wishing to avoid gelatin capsules may choose tablets as a convenient alternative.
- Liquid probiotics do not normally survive longer than just a few weeks. Another disadvantage is that microorganisms in liquid medium can mutate and change. If it is in a liquid, do not rely on it.

## How, When and Why to Use Probiotic Supplements: A Quick Summary

A number of factors are responsible for the lack of friendly cultures in our intestinal tract. Beneficial microflora are reduced by excessive use of antibiotics, chlorinated water, food preservatives, junk foods, and pollution in our environment. Seventy percent of the women in America and as high as forty percent of the men will suffer from yeast infections. Probiotics are almost always greatly lacking in the presence of a yeast infection and those who have sufficient quantities of beneficial microflora are not as susceptible to yeast infections. Studies at the VA Hospital of Minneapolis show that even amongst normal persons (with no obvious signs of poor health) there are virtually no probiotics in the gastrointestinal tract.

Health professionals recommend probiotic supplements for candidiasis (yeast infection), digestive disorders (including diarrhea and constipation), gastritis, lactose intolerance, gas, heartburn, irritable bowel syndrome, (including colitis and Crohn's disease) immune dysfunctions and as a follow up to antibiotic therapy. Under these conditions higher amounts of the probiotic supplements should be used.

For this reason, it is advisable that one should take a proven probiotic supplement daily. Probiotic supplements containing *L. acidophilus*, bifidobacterium species and FOS with two to five billion live cells (2 - 5 x 109 CFU) should be taken daily just before breakfast or between meals for maintenance. Remember, if the probiotic supplements are not refrigerated and viable, they will offer no

health benefits. Also, if these supplements are not taken in sufficient quantities, they will produce no results.

Remember that although probiotics play a key role in good health, they are not intended to be a substitute for a good healthy diet and active lifestyle. All these things work best together and the synergism of one helps the other! Use of probiotics or any other supplements for therapeutic reasons should be taken with the advice of a health professional who has knowledge and expertise in probiotics and other supplements.

# APPENDIX A
## A Glossary of Gastrointestinal Ecology

*Acidophilus:* One of numerous species of friendly flora of the gastrointestinal tract which produces many natural antibiotics such as acidolphin, lactophilin, and bacteriocidin. Acidophilus works primarily in the small intestine.

*Aerobe:* Bacteria that require oxygen in the environment to grow and multiply.

*Anaerobe or Anaerobic:* Any of a number of bacteria that grow in the absence of oxygen. Many bacteria grow only in the absence of oxygen and are said to be anaerobic bacteria.

*Antibiotic:* A large of group of chemical substances such as penicillin and streptomycin that are produced by various microorganisms and fungi and have the capacity in dilute solutions to inhibit the growth of or to destroy probiotic and pathogenic bacteria and other microorganisms and are used in the treatment of infectious diseases.

*Bacteriocidal:* Refers to substances that kill bacteria directly.

*Bacterostatic:* Refers to substances that kill bacteria indirectly by interfering with cell wall synthesis or other parts of the metabolism necessary for bacterial growth.

*Bifidobacterium:* A family of anaerobic friendly bacteria that are found in the alimentary tract and feces of infants and large intestine of adults and older people.

*Chronic Fatigue Syndrome:* Fatigue lasting longer than six months and reducing normal activity by more than fifty percent. Associated with, and likely caused by, dysbiosis.

*Dysbiosis:* A condition in which the gastrointestinal system's bacterial populations become disturbed.

*Ecosystem:* A system formed by the interaction of a community of microorganisms with its environment.

*Fermentation:* Any group of living organisms such as yeasts, molds, and certain bacteria, that cause a chemical change in the absence of oxygen that yields energy, for example, the conversion of grape sugar into ethyl alcohol.

*Flatulence:* Producing of gastrointestinal gas, the gaseous byproduct of metabolism of food. It is normal for healthy persons to pass small amounts of gas some 100 times daily.

*Flora:* The aggregate of bacteria, fungi and other microorganisms occurring on or within the body, as in intestinal flora.

*Fructooligosaccharide:* Complex groups of sugar molecules containing fructose and chains of glycogen also known as FOS. These substances are non-absorbable and difficult for the body to digest, but act as food to friendly flora of the gastrointestinal tract.

*Fungi:* A group of spore-forming organisms that, when allowed to grow, compete with normal flora, cause disease and seriously compromise homeostasis.

*Inulin:* A leading prebiotic long used in Europe and now available in the United States. Used simultaneously with probiotics to foster growth of beneficial bacteria.

*Irritable Bowel Syndrome:* Also known as IBS, this is a common functional disorder of the intestines estimated to affect 5 million Americans. The cause of IBS is not yet known. Doctors refer to IBS as a functional disorder because there is no sign of disease when the colon is examined. Doctors believe that people with IBS experience abnormal patterns of colonic movement and absorption capabilities. The IBS colon is highly sensitive, overreacting to any stimuli such as gas, stress, or eating high-fat or fiber-rich foods.

*Lactobacillus:* Most common genra of bacteria present, primarily in the small intestine, and capable of breaking down carbohydrates to form lactic acid. With many health-promoting properties, lactobacillus helps to displace toxin-producing pathogenic strains, including the prevention of cancer.

*Leaky Gut Syndrome:* A condition where the membranes of the gut are highly permeable allowing large allergenic molecules to pass into the systemic circulation and cause disease.

*Listeria:* A pathogen that causes the infectious disease called Lysteriosis, often deadly to infants and elderly. It is contracted by eating contaminated food.

*Macrophage:* The white blood cells of the immune system responsible for protection against bacteria and other pathogens. The first line of defense of the immune system.

*Natural Killer Cells:* Cells of the immune system that attack cancerous and other damaged cells.

*Peristalsis:* Progressive waves of involuntary muscle contractions and relaxations that move matter along certain tubelike structures of the body, as ingested food along the alimentary canal.

*Prebiotic:* A carbohydrate that selectively feeds beneficial bacteria in the intestinal tract and stimulates their growth. A prebiotic may be thought of as "fertilizer" for the good bacteria in the gastrointestinal tract.

*Probiotic:* That promotes life friendly bacteria in contrast to antibiotics that kill both pathogenic and friendly bacteria.

*Protozoa:* Small, parasitic organisms that can cause disease. They differ from bacteria in their structure, however, they are fully capable of causing major infectious illness.

*Steroid*: There are two major classes of corticosteroids, commonly called "steroids." Those derived from cortisone are known as anti-inflammatory steroids and are very potent anti-inflammatory agents, but known to have multiple long term deleterious side effects. When given for prolonged periods and in high doses, they will cause the overgrowth of opportunistic infectious microorganisms such as yeast, most notably candida. (The other class of steroids, known as anabolic steroids, are often used by athletes to bulk up.)

*Synbiotic*: The combination of probiotics and prebiotics.

*Synergy*: An interaction of elements that when combined produce a total effect greater than the sum of the individual elements.

*Triglycerides*: The form in which fat exists in meats, cheese, fish, nuts, vegetable oils, and the greasy layer on the surface of soup stocks or in a pan in which bacon has been fried. In a healthy person, triglycerides and other fatty substances are normally moved into the liver and into storage cells to provide energy for later use.

# APPENDIX B
## A Guide to Commonly Used Probiotics

There are many different kinds of probiotic supplements today, largely because there are so many different types of beneficial bacteria that reside within your gastrointestinal tract. As part of your foundation program, we recommend staying with the two most common and proven genras lactobacillus and bifidobacterium. Here are some of the following types of beneficial bacteria commonly supplied today in probiotic supplements.

*Lactobacillus acidophilus*-Many studies confirm the safety and efficacy of this bacteria for prevention of infectious diseases and favorably altering the intestinal microflora balance, inhibiting the growth of harmful bacteria, promoting good digestion, boosting immune function, and increasing resistance to infection. The lactobacillus is widely used in many probiotic supplements. Lactobacillus primarily works in the small intestine. This one should be part of every supplement program. Be sure to read our shopping guide so that you can be sure you purchase a strain that is known to colonize in the human gastrointestinal tract.

*Lactobacillus bulgaricus*-These friendly bacteria help reduce severity of childhood intestinal diseases, including diarrhea. This bacteria is found commonly in yogurt, and considered safe.

*Latobacillus plantarum*-This microorganism, prevalent in nearly all plant life, was identified in the human body during a study at Sweden's Lund University on the species of lactobacilli residing in the human gastrointestinal tract and subsequently those that are most implantable. In one part of the study, subjects ingested a variety of strains to determine which had successfully implanted. Five species persisted at least one day after administration, with *Lactobacillus plantarum* being the most dominant. Numerous studies have been conducted to document its health benefits and safety.

*Lactobacillus brevis* -To characterize and select lactobacillus for properties that would make them a good alternative to the use of antibiotics to treat human

vaginal infections, 10 lactobacillus strains belonging to four different lactobacillus species were analyzed for properties relating to mucosal colonization or microbial antagonism (adhesion to human epithelial cells, hydrogen peroxide production, antimicrobial activity towards *Gardnerella vaginalis* and *Candida albicans* and co-aggregation with pathogens). Three strains (including *Lactobacillus brevis*) "showed optimal properties and were, therefore, selected for the preparation of vaginal tablets," say researchers from the Institute of Microbiology, University La Sapienza, Roma, Italy. "The selected strains adhered to epithelial cells displacing vaginal pathogens; they produced high levels of [hydrogen peroxide], coaggregated with pathogens and inhibited the growth of *G. vaginalis*." Additional studies confirm that this strain can induce programmed cell death in leukemic cells. This *L. brevis* is considered safe, as noted by its inclusion on the Food and Drug Administration's generally recognized as safe (GRAS) list for microorganisms used in production of foods.

*Lactobacillus caucasicus*-Kefir dates back many centuries to the shepherds of the Caucasus Mountains, many of which live to be happily active at over 100 years of age. They discovered that fresh milk carried in leather pouches would occasionally ferment into an effervescent beverage. For most of recorded history, kefir was scarcely known outside the Caucasian Mountains. Kefir received renewed interest in the West when it was found to be a useful therapeutic treatment for patients in sanitariums. Traditionally, microflora in kefir include *Lactobacillus caucasicus*.

*Lactobacillus fermentii*-Although little information is available on this particular bacteria, it is known to play a role in vitamin $B_{12}$ metabolism; it is included on the FDA's GRAS list.

*Lactobacillus helveticus*-A considerable amount of research has been conducted to study the health benefits of fermented milks. Research on the health effects of a pasteurized sour milk, which is fermented by a starter culture containing *Lactobacillus helveticus* as the predominant microorganism, indicated clear evidence for the involvement of fermented compounds that have antihypertension properties via angiotensin-I converting enzyme inhibitory peptides. Again, this bacteria has centuries of traditional use in fermented foods, tes-

tifying to its absolute safety. Researchers from the Key Centre for Applied and Nutritional Toxicology, Melbourne, Australia, note, "Members of the genus Lactobacillus are most commonly given safe or generally recognized as safe (GRAS) status.

*Lactobacillus leichmannii*-Several studies have been conducted on the natural microbiological flora of sourdoughs from around the world. For German sour rye, the dominant lactobacilli included *L. leichmannii*. The lactobacilli secrete an antibiotic cycloheximide, which "sterilizes" the dough since it kills many (but not all) pathogenic organisms. Traditional uses confirm its safety.

*Lactobacillus lactis*-This probiotic bacteria has been shown to be inhibitory to spoilage bacteria in foods at refrigeration temperatures. This is primarily due to its production of hydrogen peroxide. In fact, this beneficial bacteria "can exert inhibitory action on *E. coli* O157:H7 at refrigeration temperatures and it may be possible to add the lactobacilli to poultry carcasses in the early stages of processing (i.e., chill tank) to exert control of this pathogen," note researchers. It is commonly found in the human intestinal tract. The FDA considers *L. lactis* (now considered a member of the bifidobacterium family) to be GRAS.

*Lactobacillus casei*-Discovered at least as early as 1935, this organism has been used by the Japanese food company Yakult Honsha in commercial products in Japan since 1955. *L. casei* been shown to implant well in the gastrointestinal tract in human trials, according to N. Yuki of the Yakult Central Institute for Microbiological Research, Tokyo, Japan. This has beneficial effects on cholesterol when studied in the laboratory. It has GRAS status.

*Bifidobacterium bifidum*-This probiotic bacteria has excellent immune-strengthening properties, especially for children, according to researchers at the Infectious Disease Department, Children's Hospital of Buffalo, State University of New York. It is GRAS.

*Bifidobacterium longum, Bifidobacterium infantis*-Probiotic bacteria which offer many health benefits. These are GRAS. Note: There are other probiotic bacteria which are used in probiotic supplements and are GRAS.

# APPENDIX C
## Drug Interactions

According to the experts at healthnotes.com, certain medicines interact with probiotics: Some interactions may increase the need for probiotics ( ☑ ). Refer to the individual drug for specific details about an interaction.

*Note: the following list only includes the generic or class name of a medicine.*

Aminoglycoside Antibiotics ☑
Amoxicillin ☑
Ampicillin ☑
Antibiotics ☑
Azithromycin ☑
Cephalosporins ☑
Chlorhexidine ☑
Ciprofloxacin ☑
Clarithromycin ☑
Clindamycin Oral ☑
Clindamycin Topical ☑
Dapsone ☑
Dicloxacillin ☑
Doxycycline ☑
Erythromycin ☑
Gentamicin ☑
Levofloxacin ☑
Loracarbef ☑

Macrolides ☑
Metronidazole ☑
Minocycline ☑
Neomycin ☑
Nitrofurantoin ☑
Ofloxacin ☑
Penicillin V ☑
Penicillins ☑
Quinolones ☑
Sulfamethoxazole ☑
Sulfasalazine ☑
Sulfonamides ☑
Tetracycline ☑
Tetracyclines ☑
Tobramycin ☑
Trimethoprim ☑
Trimethoprim/Sulfamethoxazole ☑

# APPENDIX D
**Review of Scientific Evidence for Efficacy of *Lactobacillus acidophilus* DDS-1 as a Probiotic Strain**
*Dr. S. K. Dash*

## Introduction

For more than 25 years, *Lactobacillus acidophilus DDS-1* strain has been marketed commercially worldwide as an effective probiotic strain. It has been the subject of a variety of *in vitro*, human and animal studies for more than 40 years. The focus of the efficacy research on this strain has been on its nutritional, anti-bacterial and anti-pathogenic, anti-carcinogenic and technological properties. At the same time, the microbiological and technological properties of DDS-1 have been studied.

## Identity

*Lactobacillus acidophilus* DDS-1 is a unique endogenous human strain extensively researched at University of Nebraska and is protected by US patent, and commercially manufactured and trademarked by UAS Laboratories (www.uaslabs.com). The morphological and cultural characteristics of *Lactobacillus acidophilus* DDS-1 have been determined in order to confirm the genus and species of the isolate called "Acidophilin." When grown in skim milk, the organisms were found to be Gram positive rods 0.6 to 0.9_m by 1.5 to 6.0_m, occurring singly, in pairs and in variable dimension short chains with rounded ends. These organisms were non-motile. Optimum growth temperature was 370 C and no growth occurred below 22° C or above 45° C. Further, this culture was observed to be microaerophilic and produced acid from glucose, galactose, fructose, lactose, sucrose, mannose and maltose. It had the ability to grow in acidic media and could ferment amygdalin, cellibiose and salicin. Raffinose, trehalose and dextrin were fermented very slightly. Xylose, arabinose, rhamnose, glycerol, mannitol, sorbitol, dulcitol and inositol were not fermented. Additionally, the organism grew in tomato juice both containing 2% NaCl or bile salts but not in broth containing 4% NaCl or bile salts. These characteristics are attributable to *L.acidophilus* and thus confirmed the identity of the isolate DDS-1.

## Nutritional Effects

DDS-1 produces enzymes such as proteases and lipases, which can help with the breakdown of protein and fats. Acidophilus milk (both fermented and unfermented) containing DDS-1 was shown to have a higher protein digestibility than heated milk when tested in rats. However, ability of these enzymes produced *in situ* to improve digestion has not been documented. Cultured dairy products fermented with DDS-1 had higher levels of folic acid and vitamin $B_{12}$, suggesting the metabolic ability of this strain to produce some B vitamins.

## Cholesterol

Cholesterol lowering effect of DDS-1 has been demonstrated early. Whether fermentation of milk by lactic cultures increases its anticholesteremic activity needs to be investigated further. Nevertheless, based upon his preliminary studies, Sinha reported that even unfermented sweet acidophilus milk demonstrated such an activity. He observed that feeding milk to rats had little or no effect upon their serum cholesterol while incorporation of cholesterol in the diet increased serum cholesterol. The addition of 4 million *L. acidophilus* DDS-1 cells per milliliter of milk lowered cholesterol significantly.

## Traveler's Diarrhea

The effect of *Lactobacillus acidophilus* DDS-1 supplementation on traveler's diarrhea was studied by Senhert during 1987-1989. Seventy persons participated in three studies. Each person received 2 DDS-100 Acidophilus capsules (UAS Labs) containing *Lactobacillus acidophilus* DDS-1 at the rate of 2 billion CFU per gram (2 capsules) before breakfast for a week before their trip and during the entire period of the trip to Guatemala, Mexico and Nepal. *Lactobacillus acidophilus* DDS-1 provided substantial protection against traveler's diarrhea to the individuals who received this supplement. Only two reported digestive disorders. The usual incidence on such trips is 25 to 30%.

## Bile and Acid Tolerance

Bile tolerance has been considered to be an important characteristic of *Lactobacillus acidophilus* that enables it to survive, grow, and exert its action in the small intestine. Strains that are able to grow and metabolize in the presence of physiological levels of bile should logically be more likely to survive intestin-

al transit. Studies have shown that the DDS-1 strain is capable of growing in bile concentrations of up to 3% and in vivo study demonstrated that the DDS-1 strain survives in the presence of human gastric juice.

In a preliminary study, Peterson fed 2 capsules containing $2x10^9$ CFU/gm *L. acidophilus* DDS-1 to 10 patients for three weeks and examined the stool before and after feeding. He reported 100 fold increase of *L. acidophilus* in the stool after *L. acidophilus* DDS-1 feeding of the patients. This demonstrates the survival of DDS-1 and its implantation and multiplication in the intestine.

## Impact on Fecal Microecology

The impact of feeding DDS-1 on the microflora and enzyme activities in feces of human subjects was determined (2). Low fat milk (3-8 oz glasses/d) with or without DDS-1 ($1.4x10^9$ CFU/gm) was administered to two groups each of 6 healthy adults in a crossover study. The first group received unsupplemented milk for 4 weeks and then milk with DDS-1 for 4 weeks. The second group received the DDS-1 supplemented milk for the first 4 week period and then the control milk. Results of the fecal microbiology analysis indicated that there was no change in total aerobic flora and no consistent change in coliforms. However, total lactobacilli increased by 1-2 logs. Enzyme activity assessment showed no consistent changes in b-glucosidase or b-glucuronidase activities. These results demonstrate that consumption of DDS-1 can increase levels of fecal lactobacilli.

Two trials were conducted to determine the impact of DDS-1 on physiological markers in germ-free and conventionally colonized pigs. In the first trial, the effect of oral administration of DDS-1 ($2x10^{11}$ per day for 3 consecutive days) on 5-day old germ-free pigs was determined. Three pigs were sacrificed from the control and test groups 3, 5, 7 and 9 days after DDS-1 administration. Blood and tissue (from seven gastrointestinal sites: 2 stomach sites, duodenum, jejunum, ileum, cecum and colon) were collected. Blood was evaluated for red and white cell counts, hematocrit, serum albumin, serum globulin and urea nitrogen. Tissue was evaluated for the presence of lactobacilli. DDS-1 consuming pigs had higher *L. acidophilus* counts than the controls, with concentrations the highest in the large intestine. Increased counts were maintained through 9 days post DDS-1 feeding. However, the colonic contents were not separated from the tissue, so conclusions on association of the lactobacilli with the tissue cannot be made. No impact of DDS-1 feeding on serum proteins, urea nitrogen, hematocrit or red

blood cell counts was observed. White blood cell counts increased. In the second trial with conventional animals, pigs at 2 days of age were inoculated intragastrically with DDS-1 or sterile water. All parameters for the first trial were included in the second trial in addition to assessment of weight gain and addition of coliform counts on tissues. Small to no differences in lactobacillus levels in different tissues were observed between control and treatment groups. No difference in fecal lactobacilli was observed with conventional animals, except higher levels in the cardiac region of the stomach were observed. The control group had a statistically high hematocrit than treated, but no other blood assessments were different. These results suggest mild effects of a three-day feeding regime in a conventional pig model. The short duration of the feeding regime likely contributed to these findings.

**Antibacterial and Antipathogenic Effects**

A compound with antibacterial properties is produced by DDS-1. Named 'acidophilin', this compound was isolated from milk in which DDS-1 was grown. Other *L. acidophilus* strains did not produce significant amounts of this compound. Once dried, this milk was extracted with methanol, acetone and subjected to column chromatography. Active fractions were concentrated and tested using an agar zone inhibition assay against some common food-borne pathogens. Activity against *Bacillus subtilis, Clostridium botulinum, clostridium perfringens, Escherichia coli, Proteus mirabilis, Salmonella enteritidis, Salmonella typhimurium, Staphylococcus aureus* and S*taphylococcus faecalis* was observed. As an important follow up to this in vitro demonstration of activity, Zychowicz demonstrated the effectiveness of acidophilus milk on decreasing the carrier state and on the incidence and duration of salmonella and shigella dysentery in children.

The ability of DDS-1 to inhibit *Staphylococcus aureus* was further demonstrated. *S. aureus* growth was inhibited in acidophilus yogurt likely due to a combination of activity of hydrogen peroxide, lactic acid and bacteriocin.

More recently, Yasmin et al. reported the ability of DDS-1 to inhibit in a co-culture assay *Helicobacter pylori* at ratios of 1:1 through 1:1000 (*H. pylori:L. acidophilus* DDS-1) or higher. The mechanisms and *in vivo* impact are subjects for further study.

There is growing evidence suggesting that probiotics can be effective in the prevention of recurrent urinary tract infection (UTI). The proposed mechanism of action includes inhibition of growth and adhesion of pathogens at the vaginal and urethral mucosa before ascension of these pathogens into the bladder. In a case study, L.acidophilus DDS-1 with two billion viable organisms was given twice daily for a month and followed up with once daily to patients. It showed positive effects.

***Effect on Candida albicans:*** Lactobacilli have been reported to produce hydrogen peroxide. *Lactobacillus acidophilus* DDS-1 is a producer of hydrogen peroxide. Several researchers have suggested that Lactobacilli may be used to supply hydrogen peroxide –thiocynate anti-microbial system. Evidence has been presented that thiocynate is involved in the inhibition of *Candida albicans* by certain strains of Lactobacillus acidophilus.

In a case study at a primary health care clinic, Senhert provided *Lactobacillus acidophilus* DDS-1 at the rate of 4 billion CFU/gm daily to 42 patients for a period of three months and reported improvement in 22 cases.

**Anticarcinogenic Effects**

The anti-tumorigenic properties of DDS-1 were tested in a rat model of chemically induced colon tumors. A standard diet supplemented *with* DDS-1 was fed to a group of rats injected subcutaneously with N-nitrosobis (2-oxo-propyl) amine to induce tumors. Tumor incidence was assessed at 26 and 40 weeks. At 26 weeks, the DDS-1 *fed* rats demonstrated a statistically significant reduction in tumor incidence, ornithine decarboxylase activity and metaphase arrest per crypt per hour compared to the control group. At 40 weeks, tumors in the DDS-1 group were fewer and smaller than in the control group. These results suggest that DDS-1 may delay the initiation process of chemically induced colon tumors in rats.

Methanol-acetone and silica gel fractionation extracts of DDS-1 were also evaluated *in vitro* against the KB-line and Hi-line of cancer cells in tissue culture and in a mouse model of Sarcoma-180. Morphological changes and growth inhibition of the KB cell line was observed *in vitro* and specific inhibitory activity was observed against Sarcoma-180 cells.

The mechanism of DDS-1 induced suppression of tumors was evaluated. Using a mouse macrophage cell line, investigators determined that DDS-1 was

able to stimulate the production of immune components (interleukin-1α and tumor necrosis factor-a) that are known killers or inhibitors of tumor cells. DDS-1 performed this function better than three other strains of *L. acidophilus* (NRRL 0734, NRRL 6934, NRRL B4527) or *Bifidobacterium bifidum* (strain not designated). Interestingly, the effect was also observed with heat-killed DDS-1.

## Technological Properties

With the incorporation of a patented technology from University of Wisconsin/WARF into the manufacturing of *Lactobacillus acidophilus* DDS-1 (UAS Labs) culture, *L. acidophilus* DDS-1 is stable for up to two years at ambient temperature (23° C) when blended with a recommended excipient such as low water activity microcrystalline cellulose.

Stability of *L. acidophilus* DDS-1 was tested. *L. acidophilus* DDS-1 was combined with Bifidobacterium longum at equal ratio and fortified with fructooligosaccharide at five percent rate. This supplement called DDS-Plus manufac-

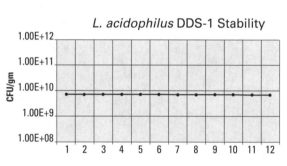

tured by UAS Laboratories was tested for potency every month for 12 months using the Standard Methods for Dairy Products (14). The stability curve shows that *L.acidophilus* DDS-1 is very stable and the loss of potency was about 7% in one year.

## Safety

*Lactobacillus acidophilus* DDS-1 has been consumed by humans as a dietary supplement or in dairy products for over 3 decades with no adverse effects. The species of L. acidophilus is recognized internationally as a safe microorganism (http://www.effca.org/anglais/pages/id_title_15.htm;.

Note: UAS Laboratories, 9953 Valley View Road, Eden Prairie, MN 55344, USA is the commercial manufacturer of *Lactobacillus acidophilus* DDS-1 and the owner of US Trademark DDS/DDS-1.

**Contact for Reprints**
Dr. S.K.Dash
UAS Laboratories
9953 Valley View Road,
Eden Prairie, MN 55344
USA
Website: www.uaslabs.com
Email: dash@uaslabs.com

# RESOURCES

**UAS Laboratories**
9953 Valley View Rd.
Eden Prairie, MN 55344
Phone: 800-422-3371, 952-935-1707
Fax: 952-935-1650
E-mail: info@uaslabs.com
Website: www.uaslabs.com

**Whole Foods Market, Inc.**
700 Lavaca St. Suite 500
Austin, TX 78701
Phone: 512-477-4455
Website: www.wholefoodsmarket.com
*Also available at all regional locations.*

**Tree of Life, Inc.**
Corporate Headquarters
P.O. Box 9000
St. Augustine, FL 32085-9000
405 Golfway West Drive
St. Augustine, FL 32095-8839
Phone: 800-260-2424, 904-940-2100
E-mail: mailbox@treeoflife.com
Website: www.treeoflife.com
*Also available at all regional locations.*

**Nature's Best**
195 Engineers Rd.
Hauppauge, NY 11788
Phone: 800-345-BEST
*Also available at all regional locations.*

**Select Nutrition Distributors**
60 Charles Lindberg Blvd., Suite 120
Phone: 516-357-0041
Fax: 516-357-0041

Probiotics are also sold at the Vitamin Shoppe, Vitamin Cottage, and other health foods stores in your neighborhood.

Note: Since not all probiotic supplements are the same, consumers should look for reputable companies selling probiotics supplements with superior strains, right potency, in viable condition, and with the right formulation. The probiotic bacteria must have generally recognized as safe (GRAS) status from the FDA.

**Other Books and Resources**
Gershon, M. *The Second Brain—Our Gut,* New York: HarperCollins, 1998

Richter, J.E. *Medical Management for Gastroesophageal Reflux Disease-1995. The American College of Gastroenterology Annual Postgraduate Course.* New York, 1995: 1a-55-61.

Sachs G., Prinz, K.C., & Hersey, J.S. *Acid-Related Disorders: Mystery to Mechanism, Mechanism to Management.* Florida: Sushu Publishing, Inc. 1995: 71-80.

The following organizations also distribute materials and support programs for patients with digestive diseases:

American Liver Foundation
1425 Pompton Avenue
Cedar Grove, NJ 07009
201-256-2550

Crohn's & Colitis Foundation of America, Inc.
386 Park Avenue South, 17th Floor
New York, NY 10016-8804
800-932-2423
212-685-3440

International Foundation for Bowel Dysfunction
P.O. Box 17864
Milwaukee, WI 53217
414-241-9479

# REFERENCES

## Chapter 1

Alvarex-Olmos MOR. Probiotic Agents and Infectious Diseases: A Modern Perspective on a Traditional Therapy. Clinical Infectious Diseases 32, 1567–1576. 2001.

Arvola T, Laiho K, Torkkeli S, Mykkanen H, Salminen S, Maunula L et al. Prophylactic Lactobacillus GG reduces antibiotic-associated diarrhea in children with respiratory infections: a randomized study. Pediatrics 1999; 104(5):e64.

Behrmann R, Vaughan V. Nelson Textbook of Pediatrics. Nelson W, editor. Thirteenth, 553-555. 1987. W.B. Saunders Company. Ref Type: Serial (Book, Monograph)

Cohen, M., "Epidemiology of drug resistance: implications for a post-antibiotic era." *Science*, 1992; 257: 1050.

Csordas A. Toxicology of butyrate and short-chain fatty acids. In Role of gut bacteria in human toxicology and pharmacology, M. Hill, ed. (Bristol: Taylor & Francis Inc.) (p 286 (1995)

Davidson GP, Butler RN. Probiotics in pediatric gastrointestinal disorders. [Review] [38 refs]. Current Opinion in Pediatrics 2000; 12(5):477-481

Eaton KK, Howard JM, Hunnisett A, and Harris M. Abnormal gut fermentation: Laboratory studies reveal deficiency of B vitamins, zinc, and magnesium. J Nutr Biochem 4 (Nov): 635-637 (1993).

Fekety R, McFarland LV, Surawicz CM, Greenberg RN, Elmer GW, Mulligan ME. Recurrent Clostridium difficilediarrhea: characteristics of and risk factors for patients enrolled in a prospective, randomized, double-blinded trial. Clinical Infectious Diseases 1997; 24(3):324-333.

Fuller R. Probiotics in man and animals, R Appl Bacteriol 1989; 66:365-378.

Gorman, C. "Healthy germs." *Time*, December 28, 1998-January 4, 1999: 197.

Gronlund MM, Arvilommi H, Kero P, Lehtonen OP, Isolauri E. Importance of intestinal colonisation in the maturation of humoral immunity in early infancy: a prospective follow up study of healthy infants aged 0-6 months. Archives of Disease in Childhood Fetal & Neonatal Edition 2000; 83(3):F186-F192.

Heinerman, J. *Super Immune Power Through a Healthy Intestinal Tract.* Québec, Canada: DynaMark Corporation Inc., 1998.

Hunnisett A, Howard J, Davies S. Gut fermentation (or the "Autobrewery") syndrome: a new clinical test with initial observations and discussion of clinical and biochemical implications. *J Nut Med* 1:33-38 (1990).

Klein J. Review of consensus reports on management of acute otitis media. Pediatric Infectious Disease Journal 18[12], 1152-1155. 1999.

Mel´nikova V.M., et al. "Problems in drug prevention and treatment of endogenous infection and dysbacteriosis." *Vestn Ross Akad Med Nauk*, 1997; (3):26-9.

Pignataa C. Budillon G, Monaco G, Nani E, Cuomo R, Parrilli G, and Ciccimarra F. "Jejunal bacterial overgrowth and intestinal permeability in children with immunodeficiency syndromes." *Gut* 1990; 31:879-882.

Pochapin M. The effect of probiotics on clostridium difficile diarrhea. American Journal of Gastroenterology 95 (Supple 1), 511-513. 2000.

Reuters. "Drug resistant bacteria found in rural U.S." September 30, 1999.

Sakata HFK. The effect of antimicrobial agents on fecal flora of children. Antimicrob Agents Chemother 29, 225-229. 1986.

The diseases and conditions discussed in this overview are covered in greater detail by fact sheets and information packets. The statistics reported in this fact sheet come from *Digestive Diseases in the United States: Epidemiology and Impact*, edited by James Everhart, M.D., MPH., NIH Publication No. 94-1447. For copies of fact sheets, information packets, or the *Digestive Diseases in the U.S.*, you may contact the National Digestive Diseases Information Clearinghouse (NDDIC), 2 Information Way, Bethesda, MD 20892-3570.

Vanderhoof J. Lactobacillus GG in the prevention of Antibiotic-associated diarrhea in children. Journal of Pediatrics 135[564], 568. 1999.

Vanderhoof, J.A. & Young, R.J. "Use of probiotics in childhood gastrointestinal disorders." *Pediatr Gastroenterol Nutr,* 1998; 27(3):323-32.

## Chapter 2

Eaton KK, Howard JM, Hunnisett A, and Harris M. Abnormal gut fermentation: Laboratory studies reveal deficiency of B vitamins, zinc, and magnesium. J Nutr Biochem 4 (Nov): 635-637 (1993).

Rao, D. & Shahani, K.M. "Vitamin content of cultured dairy products." *Cultured Dairy Prod,* 1987; 22(1): 6-10

Shahani, K.M. & Ayebo, A.D. "Role of dietary lactobacilli in gastrointestinal microecology." *Proc VI InternationalSymposium Intestinal Microecology. Am J Clin Nutr,* 1980; 33: 2448-2457.

## Chapter 3

Biller JA, Katz AJ, Flores AF, Buie TM, Gorbach SL. Treatment of recurrent Clostridium difficile colitis with Lactobacillus GG. [see comment]. Journal of Pediatric Gastroenterology & Nutrition 1995; 21(2): 224-226.

Borruel, N., et al. "Increased mucosal tumour necrosis factor alpha production in Crohn's disease can be downregulated ex vivo by probiotic bacteria." *Gut,* 2002;51(5):659-664.

Gorbach SL, Chang TW, Goldin B. Successful treatment of relapsing Clostridium difficile colitis with Lactobacillus GG. Lancet 1987; 2(8574):1519.

Joyce AM, Burns DL. Recurrent Clostridium difficile colitis. Tackling a tenacious nosocomial infection. Postgraduate Medicine 2002; 112(5):53-54.

Kelly CP, Pothoulakis C, LaMont JT. Clostridium difficile colitis. New England Journal of Medicine 1994; 330(4):257-262.

Sartor, R.B. "Therapeutic manipulation of the enteric microflora in inflammatory bowel diseases: Antibiotics, probiotics, and prebiotics." Gastroenterology. 2004 May;126(6): 1620-33.

## Chapter 4

Bazzocchi, G., et al. "Intestinal microflora and oral bacteriotherapy in irritable bowel syndrome." *Dig Liver Dis,* 2002;34 Suppl 2:S48-53.

Gorbach, S.L. "Probiotics in the third millennium." *Dig Liver Dis,* 2002;34 Suppl 2:S2-7.

King, T.S., et al. "Abnormal colonic fermentation in irritable bowel syndrome."
*Lancet,* 1998;352(9135):1187-1189.

Niedzielin, K., et al. "A controlled, double-blind, randomized study on the efficacy of
Lactobacillus plantarum 299V in patients with irritable bowel syndrome."
*Eur J Gastroenterol Hepatol,* 2001;13(10):1143-1147.

Nobaek, S., et al. "Alteration of intestinal microflora is associated with reduction in abdominal
bloating and pain in patients with irritable bowel syndrome." *Am J Gastroenterol,*
2000;95(5):1231-1238.

Pimentel, M., et al. "Eradication of Small Intestinal Bacterial Overgrowth Reduces Symptoms of
Irritable Bowel Syndrome." *Am J Gastroenterol,* 2000;95(12):3503.

Thompson, W.G. "Probiotics for irritable bowel syndrome: a light in the darkness?"
*Eur J Gastroenterol Hepatol,* 2001;13(10):1135-1136.

# Chapter 5

Bing, S.R., et al. "Protective effects of a culture supernatant of Lactobacillus acidophilus and
antioxidants on ileal ulcer formation in rats treated with a nonsteroidal antiinflammatory
drug." *Microbiol Immunol,* 1998;42(11):745-753.

Cremonini, F., et al. "Effect of different probiotic preparations on anti-helicobacter pylori
therapy-related side effects: a parallel group, triple blind, placebo-controlled study."
*Am J Gastroenterol,* 2002 Nov;97(11):2744-2749.

Cremonini, F., et al. "Helicobacter pylori treatment: a role for probiotics?" *Dig Dis,*
2001;19(2):144-147.

Oh, Y., et al. "Folk yoghurt kills Helicobacter pylori." *J Appl Microbiol,* 2002;93(6):1083-1088.

# Chapter 6

Fernandes, C.F. & Shahani, K.M. "Lactose intolerance and its modulation with lactobacilli and
other microbial supplements." *J Appl Nutr,* 1989; 41: 50-64.

Fernandes, C.F., et al. "Therapeutic role of dietary lactobacilli and lactobacillic fermented dairy
products." *FEMS Microbiol Rev,* 1987; 46: 343-356.

Gilliland, S.E. "Health and nutritional benefits from lactic acid bacteria." FEMS Microbial Rev, 1990; 87: 175-188.

Lee, H., et al. "Factors affecting the protein quality of yogurt and acidophilus milk." *J Dairy Sci,* 1988; 71: 3203-3214.

## Chapter 7

Hollander, D. "Intestinal permeability, leaky gut, and intestinal disorders." *Curr Gastroenterol Rep,* 1999;1(5):410-416.

Isolauri, E. "Studies on Lactobacillus GG in food hypersensitivity disorders." *Nutrition Today,* 1996;31(6):supplement 1:28S-31S.

Keshavarzian, A., et al. "Leaky gut in alcoholic cirrhosis: a possible mechanism for alcohol-induced liver damage." *Am J Gastroenterol,* 1999;94(1):200-207.

Madsen, K., et al. "Probiotic bacteria enhance murine and human intestinal epithelial barrier function." *Gastroenterology,* 2001;121(3):580-591.

Madsen, K.L. "The use of probiotics in gastrointestinal disease." Can J Gastroenterol, 2001;15(12):817-822.

Salminen, S. & Saxelin, M. "Comparison of successful probiotic strains." Nutrition Today, 1996;31(6):supplement 1:32S-34S.

Schwarz, B. "[Intestinal ischemic reperfusion syndrome: pathophysiology, clinical significance, therapy]." Wien Klin Wochenschr, 1999;111(14):539-548.

## Chapter 8

de Vrese, M, et al. "Probiotics–compensation for lactase insufficiency." *Am J Clin Nutr,* 2001;73(2 Suppl):421S-429S.

## Chapter 9

Fernandes, C.F., et al. "Control of diarrhea by lactobacilli." *J Appl Nutr,* 1988; 40: 32-43.

Fernandes, C.F., et al. "Effect of nutrient media and bile salts on growth and antimicrobial activity of L. acidophilus." *J Dairy Sci,* 1988; 71: 3222-3228.

Kopeloff, N. "Clinical results obtained with bacillus acidophilus." *Arch Int Med,* 1924; 33: 47.

*Lancet general Advertiser,* September 21, 1957.

Ouwehand, A.C., et al. "Effect of probiotics on constipation, fecal azoreductase activity and fecal mucin content in the elderly." *Ann Nutr Metab,* 2002;46(3-4):159-162.

Rettger, L.F., et al. *Lactobacillus acidophilus. Its therapeutic application.* New Haven: Yale University Press, 1935.

Weinstein, L., et al. "Therapeutic application of acidophilus milk in simple constipation." *Arch Int Med,* 1933; 52: 384.

# Chapter 10

Cross, M.L. "Microbes versus microbes: immune signals generated by probiotic lactobacilli and their role in protection against microbial pathogens." *FEMS Immunol Med Microbiol,* 2002;34(4):245-253.

Fang, H., et al. "Modulation of humoral immune response through probiotic intake." *FEMS Immunol Med Microbiol,* 2002;29(1):47-52.

Gill, H.S., et al. "Enhancement of immunity in the elderly by dietary supplementation with the probiotic *Bifidobacterium lactis* HN019." Am J Clin Nutr, 2001;74(6):833-839.

Isolauri, E. "Probiotics in human disease." *Am J Clin Nutr,* 2001;73(6):1142S-1146S.

Isolauri, E., et al. "Probiotics: effects on immunity." *Am J Clin Nutr,* 2001;73(2):444S-450S.

Park, J.H., et al. "Encapsulated Bifidobacterium bifidum potentiates intestinal IgA production." *Cell Immunol,* 2002;219:1:22-27.

Reddy, G.V., et al. "Natural antibiotic activity of *L. acidophilus and bulgaricus.* III. Production and partial purification of bulgarican from *L. bulgaricus.*" *Cultured Dairy Pro J,* 1983; 18(2): 15-19.

Schiffin, E., et al. *American Journal of Clinical Nutrition,* 1997; 66: 515S-520S.

Shahani, K.M. & Ayebo, A.D. "Role of dietary lactobacilli in gastrointestinal microecology." *American Journal of Clinical Nutrition,* 1980; 33: 2448-2457.

Shahani, K.M., et al. "Antibiotic acidophilus and the process for preparing the same." U.S. Patent 3,689,640, September 5, 1972.

Shahani, K.M., et al. *Cultured Dairy Products Journal,* 1977; 12: 8-11.

Thorwald, J. *Science and Secrets of Early Medicine.* New York: Harcourt, Brace & World, 1963, pp. 84-87.

Turchet, P., et al. "Effect of fermented milk containing the probiotic Lactobacillus casei DN-114 001 on winter infections in free-living elderly subjects: a randomised, controlled pilot study." *J Nutr Health Aging,* 2003;7(2):75-77.

# Chapter 11

Kirjavainen, P.V., et al. "Characterizing the composition of intestinal microflora as a prospective treatment target in infant allergic disease." *FEMS Immunol Med Microbiol,* 2001;32(1):1-7.

Kuvaeva, I., et al. "The microecology of the gastrointestinal tract and the immunological status under food allergy." *Nahrung,* 1984; 28(6-7): 689-693.

Reuters Health. "'Good' bacteria may thwart allergies in toddlers." May 30, 2003.

# Chapter 12

"Effect of lactobacillus immunotherapy on genital infections in women (Solco/Gynatren)." *Geburtshilfe Fraunheilkd,* 1984; 44(5): 311-314.

Beard, C.M., et al. "Lack of evidence for cancer due to use of metronidazole." *The New England Journal of Medicine,* 1979; 301(10): 519-522.

Cavaliere, A., et al. "Induction of mammary tumors with metronidazole in female Sprague-Dawley rats." Tumori, 1984; 70: 307-311.

Danielson, D.A., et al. "Metronidazole and cancer." *Journal of the American Medical Association,* 1982; 247(18): 2498-2499

Elmer, G. (1996). "Biotherapeutic Agents: A Neglected Modality for the Treatment and Prevention of Selected Intestinal and Vaginal Infections" *Journal of the American Medical Association,* 275(11): 873.

Fredricsson, B., et al. "Gardnerella-associated vaginitis and anerobic bacteria." *Gynecol. Obstet. Invest.,* 1984; 17(5): 236-241.

Karkut, G. "Effect of lactobacillus immunotherapy on genital infections in women (Solco Trichovac/Gynatren)." *Geburtshilfe Fraunheilkd,* 1984; 44(5): 311-314.

Litschgi, M.S., et al. "Effectiveness of a lactobacillus vaccine on trichomonas infections in women. Preliminary results." *Fortschr. Med.,* 1980; 98(41): 1624-1627.

Mintz, M. "FDA evaluates link between cancer, drug." *The Washington Post,* January 21, 1976.

Relondo-Lopez, V. (1990). "Emerging Role of Lactobacilli in the Control and Maintenance of the Vaginal Bacterial Microflora." *Reviews of Infectious Diseases,* 12(5): 856-72.

Rustia, M. & Shubik, P. "Experimental induction of hepatomas, mammary tumors, and other tumors with metronidazole in nonbred Sas:MRC(WI)BR rats." *Journal of the National Cancer Institute,* 1979; 63: 863-868.

Spiegel, C.A., et al. "Anaerobic bacteria in nonspecific vaginitis." *The New England Journal of Medicine,* 1980; 303(11): 601-607.

Spiegel, C.A., et al. "Diagnosis of bacterial vaginosis by direct gram stain of vaginal fluid." *J. Clin. Microbiol.,* 1983; 18(1): 170-177.

Will, T.E. "Lactobacillus overgrowth for treatment of moniliary vulvovaginitis." Letter to the editor. *Lancet,* 1979; 2: 482.

# Chapter 13

Asahara, T., et al. "Antimicrobial activity of intraurethrally administered probiotic *Lactobacillus casei* in a murine model of *Escherichia coli* urinary tract infection." *Antimicrob Agents Chemother,* 2001; 45(6): 1751-1760.

Bruce, A.W. & Reid, G. "Probiotics and the urologist." *Can J Urol,* 2003; 10(2): 1785-1789.

Chandan, R.C.Y., et al. "Competitive exclusion of uropathogens from human uroepithelial cells by lactobacillus." *Infect Immun,* 1985; 47: 84-89.

## Chapter 14

"The poop on probiotics." Natural Foods Merchandiser, January 1999; 55.
C. difficile diarrhoea." *Int Microbiol,* 2004;7(1):59-62.

Clements, M.L., et al. "Exogenous lactobacilli fed to man—their fate and ability to prevent diarrheal disease. *Prog Food Nutr Sci,* 1983;7:29-37.

D'Angelo, G., et al. "Probiotics in childhood." *Minerva Pediatr,* 1998; 50(5):163-73.

Korshunov. V.M., et al. "Correction of intestinal microflora in chemotherapeutic dysbacteriosis using bifidobacterial and lactobacterial autologous strains." *Zh Mikrobiol Epidemiol Immunobiol,* 1985;9:20-25.

Niv, M., et al. "Yogurt in the treatment of infantile diarrhea." *Clin. Ped.,* 1963; 2: 407-411.

Oli, M.W., et al. "Evaluation of fructooligosaccharide supplementation of oral electrolyte solutions for treatment of diarrhea: recovery of the intestinal bacteria." *Dig Dis Sci,* 1998; 43(1):138-147.

Plummer, S., et al. "*Clostridium difficile* pilot study: effects of probiotic supplementation on the incidence of C. difficile diarrohea." Int Microbial, 2004; 7(1):59-62

Witsell, D.L., et al. "Effect of *Lactobacillus acidophilus* on antibiotic-associated gastrointestinal morbidity: a prospective randomized trial." *J Otolaryngol,* 1995;24:230-233.

## Chapter 15

Am J Clin Nutr 1974 May;27(5):464-9.Studies of a surfactant and cholesteremia in the Maasai.

Anderson, J.W. & Gilliland, S.E. "Effect of fermented milk (yogurt) containing *Lactobacillus acidophilus* L1 on serum cholesterol in hypercholesterolemic humans." *J Am Coll Nutr,* 1999;18(1):43-50.

Atherosclerosis 1977 Mar;26(3):335-40 A factor in yogurt which lowers cholesteremia in man. Mann GV.

Davidson, M.H. & Maki, K.C. "Effects of dietary inulin on serum lipids." *Journal of Nutrition,* 1999 129(7 Suppl): 1474S-1477S.

Grunewald, K. K. 1982. Serum cholesterol levels in rats fed skim milk fermented by *Lactobacillus acidophilus* . J. Food Sci. 47:2078-2079

Harrison VC, Peat G. Serum cholesterol and bowel flora in the newborn. *Am J Clin Nutr,* 1975 Dec;28(12):1351-5.

Hepner, G., Fried, R., Jeor, S. S., Fusetti, L. & Morin, R. 1979. "Hypocholesteremic effect of yogurt and milk." *Am J Clin Nutr* 32: 19-24.

Lipids 1973 Jul;8(7):428-31 Lowering of serum cholesterol by intestinal bacteria in cholesterol-fed piglets. Mott GE, Moore RW, Redmond HE, Reiser R. Mott GE, Moore RW, Redmond HE, Reiser R.

Sci 1975 Nov;54(6):1935-8 The influence of intestinal (ceca) flora on serum and egg yolk cholesterol levels in laying hens. Tortuero F, Brenes A, Rioperez J.

Roberfroid, M.B. "Functional effects of food components and the gastrointestinal system: chicory fructooligosaccharides." *Nutr Rev,* 1996; 54(11 Pt 2):S38-42.

Williams, C.M. "Effects of inulin on lipid parameters in humans." *J Nutr,* 1999; 129(7 Suppl):1471S-1473S. Mann GV.

# Chapter 16

Bottazzi, V., et al. "Properta antitumorali dei batteri latticie degl. Alimenti fermentati con batteri lacttici." *Il Latte,* 1985; 10: 873-879.

Burns, A.J. & Rowland, I.R. "Anti-carcinogenicity of probiotics and prebiotics." *Curr Issues Intest Microbiol,* 2000;1(1):13-24.

El-Nezami, H., et al. "Biologic control of food carcinogens with use of Lactobacillus GG." Nutr Today 1996;31(6);Suppl 1:41S-42S.

Fernandes, C.F., et al. "Mode of tumor suppression by *Lactobacillus acidophilus.*" *J Nutr Medicine,* 1991; 2: 25-34.

Goldin, B. & Gorsbach, S. "The effect of milk and lactobacillus feeding on human intestinal bacterial enzyme activity." *American Journal of Clinical Nutrition,* 1984; 39: 756-761.

Goldin, B.R., et al. "Effect of diet and Lactobacillus acidophilus supplements on human fecal bacterial enzymes." *J Natl Cancer Inst,* 1980;64(2):255-261.

Gorbach, S.L. "The intestinal microflora and its colon cancer connection." *Infection,* 1982; 10(6): 379-384.

Lee, H., et al. "Anticarcinogenic effect of Lactobacillus acidophilus on N-nitrosobis (2-oxopropyl)amine induced colon tumor in rats." *J Appl Nutr,* 1996; 48: 59-66.

Liebman, B. "Diet & disease: the story so far." *Nutrition Action Health Letter,* 1999; 26(10): 1, 3-9.

O'Mahony, L., et al. "Probiotic impact on microbial flora, inflammation and tumour development in IL-10 knockout mice." *Aliment Pharmacol Ther,* 2001;15(8):1219-1225.

Rafter, J.J. "Scientific basis of biomarkers and benefits of functional foods for reduction of disease risk: cancer." *Br J Nutr,* 2002;88 Suppl 2:S219-224.

Reddy, B.S. "Possible mechanisms by which pro- and prebiotics influence colon carcinogenesis and tumor growth." *Journal of Nutrition,* 1999; 129(7 Suppl): 1478S-1482S.

Taper, H.S. & Roberfroid, M. "Influence of inulin and oligofructose on breast cancer and tumor growth." *Journal of Nutrition,* 1999; 129 (7 Suppl): 1488S-1491S.

Kohlmeier, L., et al. "Lifestyle trends in worldwide breast cancer rates." *Trends in Cancer Mortality in Industrial Countries.* New York, NY: The New York Academy of Sciences, 1990.

Podell, R.N. "Bacteria that strengthen the immune system." *Health & Nutrition Breakthroughs,* February 1998: 12.

## Chapter 18

DuPont, H. L. "*Lactobacillus* GG in prevention of traveler's diarrhea: an encouraging step." *J Travel Med,* 1997;4:1-2.

Oksanen, P., et al. "Prevention of traveller's diarrhea by *Lactobacillus* GG." *Ann Med,* 1990;22:53-56.

# Chapter 19

Brudnak, M.A. "Probiotics as an adjuvant to detoxification protocols." *Med Hypotheses,*
2002;58(5):382-385.

Garvey, J. "Diet in autism and associated disorders." *J Fam Health Care,* 2002;12(2):34-38.

Pinesap, J. "A neurochemical theory of autism." *Trends in Neuroscience.* 1979;2:174-177.

Quigley, E.M.M. & Hurley, D. "Autism and the gastrointestinal tract [editorial]."
*Am J Gastroenterol,* 2000;95(9):2154-2156.

Reichelt, K.L., et al. "Childhood autism: a complex disorder." *Biol. Psychiatry,*
1986;21:1279-1290.

Reichelt, K.L., et al. "Gluten, milk proteins and autism: dietary intervention effects on behaviour
and peptide secretion." *Journal of Applied Nutrition,* 1990;42(1);1-11.

Sandler, R.H., et al. "Short-term benefit from oral vancomycin treatment of regressive-onset
autism." *J Child Neurol,* 2000;15(7):429-435.

Wakefield, A.J., et al. "Enterocolitis in children with developmental disorders."
*Am J Gastroenterol,* 2000;95(9):2285-2295.

# Chapter 20

Brenna, M., et al. "Prevalence of viable *lactobacillus acidophilus* in dried commercial products."
*J Food Prot,* 1983; 46: 887-892.

Gilliland, S.E. & Speck, M.L. "Enumeration and identity of lactobacilli in dietary products."
*J Food Prot,* 1977; 40: 760-762.

# Appendix B

Beishir, L. *Microbiology in Practice,* 1983. New York: Harper and Row.

Boudraa, G., et al. "Effect of feeding yogurt versus milk in children with acute diarrhea and
carbohydrate malabsorption." *J Pediatr Gastroenterol Nutr,* 2001;33(3):307-313.

Brashears, M.M., et al. "Antagonistic action of cells of *Lactobacillus lactis* toward *Escherichia
coli* O157:H7 on refrigerated raw chicken meat." *J Food Prot,* 1998;61(2):166-170.

Brashears, M.M., et al. "Bile salt deconjugation and cholesterol removal from media by *Lactobacillus casei.*" *J Dairy Sci,* 1998;81(8):2103-2110.

Di Marzio L., et al. "Apoptotic effects of selected strains of lactic acid bacteria on a human T leukemia cell line are associated with bacterial arginine deiminase and/or sphingomyelinase activities." *Nutr Cancer,* 2001;40(2):185-196.

Donohue, D.C. & Salminen, S. "*Safety of probiotic bacteria.*" *Asia Pacific J Clin Nutr* (1996) 5: 25-28.

Johansson, M.L., et al. "Administration of different Lactobacillus strains in fermented oatmeal soup: *in vivo* colonization of human intestinal mucosa and effect on the indigenous flora." *Applied and Environmental Microbiology,* 1993;59:15-20.

Mastromarino, P., et al. "Characterization and selection of vaginal Lactobacillus strains for the preparation of vaginal tablets." *J Appl Microbiol,* 2002;93(5):884-893.

Qiao, H., et al. "Immune responses in rhesus rotavirus-challenged BALB/c mice treated with bifidobacteria and prebiotic supplements." *Pediatr Res* 2002;51(6):750-755.

Takano, T. "Milk derived peptides and hypertension reduction." *International Dairy Journal,* 1998;8(5/6) 375-381.

Yuki, N. "Survival of a probiotic, *Lactobacillus casei* strain Shirota, in the gastrointestinal tract: selective isolation from faeces and identification using monoclonal antibodies." *Int J Food Microbiol* 1999;48(1):51-57.

# Appendix D

Attaie, R., Whalen, P.J., Shahani, K.M., Amer, M.A. 1987. Inhibition of growth of *S. aureus* during production of acidophilus yogurt. *J Food Protect,* 50:224-228.

Ayebo, A.D., Angelo, I.A., Shahani, K.M. 1980. Effect of ingesting *Lactobacillus acidophilus* milk upon fecal flora and enzyme activity in humans. *Milchwissenschaft,* 35:730-733.

Borriello, S.P., Hammes, W.P., Holzapfel, W., Marteau, P., Schrezenmeir, J., Vaara, M., Valtonen, V. 2003. Safety of probiotics that contain lactobacilli or bifidobacteria. *Clin Infect Dis,* 36(6):775-80.

Collins, E.B., Aramaki, K. 1980. Production of hydrogen peroxide by *Lactobacillus acidophilus*. *J Dairy Sci*, 63: 353-7.

DePablo, J., Miller, D., Conrad, P. and Corti, H. 2003. Preservation and Storage Medium For Biological Materials (US Patent No. 6,653,062 B1).

Eschenbach, D.A., Davick, P.R., Williams, B.L., Klebanoff, S.J., et.al. 1989. Prevalence of hydrogen peroxide producing lactobacillus species in normal women and women with bacterial vaginitis. *J Clin Microbiol,* 27:251-46.

Gasser, F. 1994. Safety of lactic acid bacteria and their occurrence in human clinical infections. *Bull Inst Pasteur,*. 92:45-67.

Gerasimov, S.V. 2003. Probiotic prophylaxis in Pediatric Recurrent Urinary Tract Infection.

Jack, M., Wood, B.J.B., Berry, D.R. 1990. Evidence for the involvement of thiocyanate in the inhibition of *Candida albicans* by *Lactobacillus acidophilus*. *Microbioscience,* 62:37-46.

Klebanoff, S.J., Smith, D.C. 1970. Peroxidase-mediated antimicrobial activity of rat uterine fluid. *Gynecol Invest,* 1:21-40

Lee, H., Friend, B.A., Shahani, K.M. 1988. Factors affecting the protein quality of yogurt and acidophilus milk. *J Dairy Sci,* 71:3203-3214.

Lee, H., Rangavajhyala, N., Grandjean, C., Shahani, K.M. 1996. Anticarcinogenic effect of *Lactobacillus acidophilus* on N-nitrosogis (2-oxopropyl) amine induced colon tumor in rats. *J Appl Nutr* 48:59-66.

Marshall, V., Philips, S.M., Turvey, A. 1982. Isolation of a hydrogen peroxide producing strain of lactobacillus from calf gut. *Res Vet Sci*, 32:259-60

Marshall, Robert T. and American Public Health Association 1993. Standard Methods for the Examination of Dairy Products, 16th Edition 213-246.

Pollman, D.S., Danielson, D.M., Wren, W.B., Peo, E.R., Jr., Shanani, K.M. 1980. Influence of *Lactobacillus acidophilus* inoculum on gnotobiotic and conventional pigs. *J Animal Sci*, 51:629-637.

Peterson, L. 1998. Studies on DDS-Acidophilus at VA Hospital, Minneapolis.

Rangavajhyala, N., Shahani, K.M., Sridevi, G., Srikumaran, S. 1997. Nonlipopolysaccharide components of *Lactobacillus acidophilus* stimulate the production in interleukin-1 alpha and tumor necrosis factor-alpha by murine macrophages. *Nutr Cancer,* 28:130-134.

Rao, D. R., Shahani, K.M. 1987. Vitamin content of cultured diary products. *Cult Dairy Prod J,* 22:6-10.

Sanders, M.E., Walker, D.C., Walker, K.M. et al. 1996. Performance of commercial cultures in fluid milk applications. *J Dairy Sci,* 79:943-55.

Senhert, K.W. 1988-89. Effect of DDS-Acidophilus, A Case Study.

Shahani, K.M. 1969. Isolation and study of anticarcinogenic agents from lactobacillus fermented food systems. Final Report. Damon Runyan Memorial Fund for Cancer Research, Inc.

Shahani, K.M., Vakil, J. R., Kilara, A. 1976. Natural antibiotic activity of *L. acidophilus* and bulgaricus. I. Cultural conditions for the production of antibiosis. *Cult Dairy Prod J,* 11:14-17.

Shahani, K.M., Vakil, J. R., Kilara, A. 1977. Natural antibiotic activity of *L. acidophilus* and bulgaricus. II. Isolation of acidophilin from *L. acidophilus. Cult Dairy Prod J,* 12:8-11.

Sinha, D.K. 1978. Development of unfermented acidophilus milk and its properties. Ph.D. thesis, University of Nebraska, Lincoln.

Tramer, J. 1966. Inhibitory effect of *L.acidophilus. Nature,* 211:204-205

Vakil, J.R., Shahani, K.M. 1965. Partial purification of antibacterial activity of *Lactobacillus acidophilus, Bact Proc,* P.9.

Walker, D.K., Gilliland, S.E. 1993. Relationships among bile tolerance, bile salt deconjugation and assimilation of cholesterol by *Lactobacillus acidophilus, J Dairy Science,* 76:956-61.

Yasmin T, Stohs SJ, Chatterjee A, Bagchi D. 2002. Inhibition of Helicobacter pylori by *Lactobacillus acidophilus* DDS1, clarithromycin, Protykin and garcinol. Abstracts of the General Meeting of the American Society for Microbiology, 102, p. 166.

Zychowicz, C., Surazynska, A., Siewierska, B., Cleplinska, T. 1977. Results of administration of *Lactobacillus acidophilus* cultures (acidophilus milk) in an endemic focus of dysentery. *Pediatria Polska*, 50:429.

Zychowicz, C., Kowalczyk, S., Cleplinska, T. 1974. Effect of *Lactobacillus acidophilus* cultures (acifdophilus milk) on the carrier state of shigella and salmonella organisms in children. *Pediatria Polska*, 49:997.

# INDEX

## ABOUT THE AUTHOR

D r. Dash is the founder and President of UAS Laboratories, the leading probiotic company since 1979. Dr. Dash has set quality control standards for probiotics (CFU/gm), which are now used worldwide. He is the first to commercialize superstrain DDS-1 *L. acidophilus*, which is acid resistant and bile resistant. He has introduced nitrogen packaging that enables stability of probiotics. Dr. Dash is the first to introduce non-dairy probiotics and fortification of prebiotics (fructooligosaccharides) with probiotics. Dr. Dash's probiotics, DDS-Probiotics, have been top sellers in the United States and Canada since 1979. DDS-Probiotics are backed by U.S. Trademark, Patent, and medical research and are listed in *Physicians' Desk Reference*.

Dr. Dash says, "A probiotic supplement can only be effective if it contains the right strain(s), in the right number (potency), in the right condition (viable), and in the right formulation." And it must have generally recognized as safe (GRAS) status by the FDA.

For more information about Dr. Dash and his pioneering work, visit www.uaslabs.com.